Postcard History Series

Harford County
in Vintage Postcards

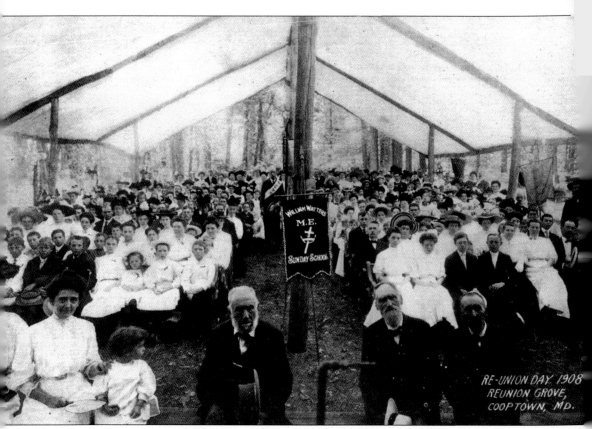

COOPTOWN, WILLIAM WATTERS M.E. CHURCH REUNION DAY, 1908. In every corner of the county, faith and church help to keep families, friends, and neighbors together as a community. In this photo, the Methodist churches of the West Harford Circuit have gathered at Reunion Grove for an annual tent meeting. (Courtesy the Historical Society of Harford County, Inc.)

Postcard History Series

Harford County
in Vintage Postcards

Bill Bates

ARCADIA

Copyright © 2005 by Bill Bates
ISBN 0-7385-1787-9

Published by Arcadia Publishing
Charleston SC, Chicago IL, Portsmouth NH, San Francisco CA

Printed in Great Britain

Library of Congress Catalog Card Number: 2004117953

For all general information contact Arcadia Publishing at:
Telephone 843-853-2070
Fax 843-853-0044
E-mail sales@arcadiapublishing.com
For customer service and orders:
Toll-Free 1-888-313-2665

Visit us on the internet at http://www.arcadiapublishing.com

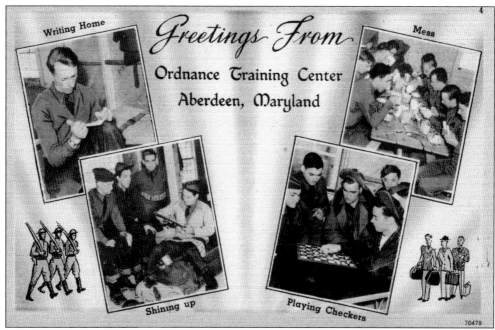

ABERDEEN, ORDNANCE TRAINING CENTER. One of the first orders that new army recruits receive is to write home to tell their families they are fine. Soldiers are provided with postcards such as this early card showing life on base. It's meant to reassure the folks back home: boys arrive and become a team of fighting men. (Courtesy the Historical Society of Harford County, Inc.)

Contents

Acknowledgments 6

Introduction 7

1. From the Top 9
2. Darlington, Berkley, and Dublin 15
3. Along the Susquehanna 25
4. Havre de Grace 31
5. Aberdeen and APG 43
6. Original Harford 57
7. Bel Air, Churchville, and Level 69
8. Watervale, Fallston, and Ladew 87
9. Jarrettsville to Rocks and Deer Creek 95
10. Portraits, Ads, and More 115

ACKNOWLEDGMENTS

Dear Reader, I want to thank you for your interest in this book. Without your concern for the past, the historical and natural treasures that still exist in our county would have little hope for survival. I'm thrilled to bring you the 224 historic images in this book, carefully selected from over 1,000 postcards from private and public collections. I hope you enjoy this and future books on Harford County history. Please visit www.harfordbooks.com for additional information and future book plans.

Thanks to Maryanna Skowronski, Richard Herbig, the board, and the volunteer staff of the Historical Society of Harford County for their support of this project. The care of much of our precious Harford history is in the good and caring hands of these magnificent volunteers.

Thanks to Richard Sherrill and Emily Bates for their help with the Harford County map on page eight. Richard was invaluable for solving questions about some of the postcard images; he is the "go-to" guy for the history of the Susquehanna region.

Thanks to the following for their time, consideration, information, stories, connections, leads, updates, and/or offers to share their collections: Ray Bent, Jim Bierer, Thirza Brandt, Scott Calkins, Audra Caplan, Jim Chrismer, Dot Corbin, Charlotte Cronin, James Dalmas, Dorothy Francis, Charlie Getscher, Bev Gordon, Dr. Stuart Gordon, Benjamin Kurtz, Gary Helton, Mary Henderson, Marlene Herculson, Dr. David Hodge, Harry Hopkins, Jim Kropp, Michelle Louderback, Leo Matrangola, the folks at Mary Martin Postcards, Kit Mueller, Linda Noll, Joan Nugent, James Paquette, Elizabeth Preston, Ellis Reeves, Jim Richardson, Bill Seccurro, Nancy Sheetz, Kat Squires, Mary Streett, Richard Tome, Cathy Vincente and the folks at the Havre de Grace Visitors Center, Susan Walter, Doug Washburn, Bowen Weisheit, David Wells, Chris Wilson, the members of the Bel Air American History Club, and the many folks who shared their memories, stories, and good wishes at signings and events for my first book, Images of America: Bel Air.

A book is most successful when people talk it up. Thanks to the enthusiastic boosters who spread the word about Images of America: Bel Air. Thanks to those who booked me to speak or sign. Thanks to those who carry the book in their store and keep reordering.

Thanks to the best support team an author could want: my editor, Lauren Bobier, and the entire Arcadia staff.

Thanks to Lois Nagle for magically being there and helping every time I turned around.

As always, thanks to Mary Ellen, Geoff, and Emily for their love and support.

INTRODUCTION

Pity poor Capt. John Smith. He sailed with 12 men from the Jamestown settlement in Virginia in 1608 to explore the Chesapeake Bay and its waters. Upon entering the Susquehanna River, he saw fish so great in number that they seemed to be piled on top of each other. His lament was that their frying pans were not of the right shape to catch the fish. I'm sure a handy mate showed him what a net was for.

Many ships brought settlers to Maryland shores in the years following, including the *Ark,* the *Dove,* the *Constant Friendship,* and the ship that brought Edward Palmer, in 1622, the earliest adventurer to settle in what would become, in 1659, first Baltimore County and then, in 1773, Harford County.

It's too bad Smith and Palmer didn't have picture postcards to send to the folks back home in England. We're fortunate that visitors to our county as well as residents did have picture postcards beginning in the late 1800s. Postcards give us a visual record of life in Harford County during the past 100 years.

Harford has always been in a great position to attract travelers. Our towns lie on major roads and waterways between major cities to our south and north. Harford has always been a great stopping-over point. People would also come from urban settings like Baltimore and Philadelphia to spend a few days or an entire summer in the country away from the concentrated heat and smell of the city.

Of course, travel took longer a century ago. Horses can carry a human or pull a wagon or buggy only so far before they need rest and refreshment (the horses, that is—actually, the people, too). To accommodate travelers, even the smallest towns had at least one hotel and the bigger towns had many. And many of the hotels made postcards with pictures of their establishments and local sights. Hotel owners used them to send thank-you notes to guests and entice them back. Guests used them to send quick notes to friends and family.

But postcards weren't just for travelers. The new medium of photo postcards allowed folks at home to have postcards made showing their businesses, their churches, their homes, and even their own portraits. They'd use them as very personalized stationery, literally showing the most important things and people in their lives to folks miles away who might never get to visit.

It's that personal element that makes this book so special. These postcards make up a portrait of the people and their lives from every corner of Harford County. It's where we live now but shown as it was as far back as 100 years ago—as spectacular as huge floods and massive ice floes, railroad wrecks, and training for a world war, and as mundane as waiting for a train on a hot day or sitting on your own front porch to catch a cool breeze when the day's work is done.

The pictures are organized by location. The dates listed in boldface type as part of the card's title represent the postmark and not necessarily the date of the photo. Because postcards do not carry copyright dates, the postmark, when available, is the surest way to date the card.

You may have questions or comments about something in this book, or you might have postcards, photos, or stories for me to include in future books about Harford County. I'd love to hear from you. Send e-mail to bill@harfordbooks.com.

If you'd like to know more about this book or more about Harford County, visit www.harfordbooks.com. You'll find a list of written and online resources, additional images, and more about specific images from this book. There is also a rationale for how I selected the images and, for collectors, notes on the rarity of some of these cards.

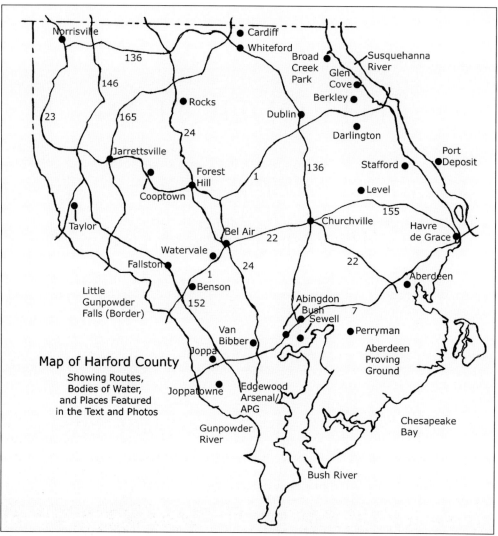

MAP OF HARFORD COUNTY. This map locates many of the places pictured in this book. Some of the towns, such as Forest Hill, still exist with a busy crossroads, stores, and post office. Others, such as Van Bibber, are remembered by the road that replaced the buildings that stood there. Note how the county is defined by water on three sides: the Susquehanna on the upper right, the Chesapeake Bay on the lower right, and the Little Gunpowder Falls on the lower left side. These major waterways and their tributaries have helped to shape Harford's rich history. (Original map by Bill Bates, Emily Bates, and Richard Sherrill.)

One
FROM THE TOP

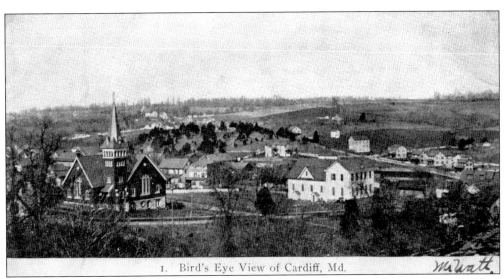

1. Bird's Eye View of Cardiff, Md.

CARDIFF, BIRD'S EYE VIEW, 1908. This chapter begins at the northwest end of Harford County in Norrisville, moving eastward to the slate region of Cardiff and Whiteford, and over to the Boy Scout camp at Broad Creek. The range of Harford's geography is especially noticeable at its northern end. The gentle farmland hills in the west give way to a slate ridge that runs 12 miles through the upper central land into neighboring Delta, Pennsylvania. The east end is ruled by the Susquehanna River. (Courtesy the Historical Society of Harford County, Inc.)

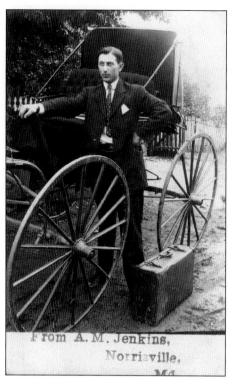

NORRISVILLE, A.M. JENKINS, 1908. "This is to let you know that I am starting your way." Jenkins appears to have been a traveling representative of some kind—have case, will travel (by horse and buggy)—headed for Lewisberg, Pennsylvania, on July 28, 1908. Perhaps Norrisville was a good central point to reach customers in Maryland and neighboring York County, Pennsylvania. (Courtesy the Historical Society of Harford County, Inc.)

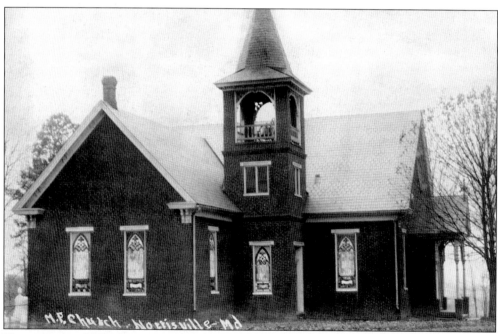

NORRISVILLE, M.P. CHURCH, 1911. According to C. Milton Wright, Norrisville was named after the Methodist Protestant church, which was paid for with a gift from Daniel Norris in 1856. Today we'd call that savvy branding. In 1885, the church was replaced with the larger one pictured here. (Courtesy the Historical Society of Harford County, Inc.)

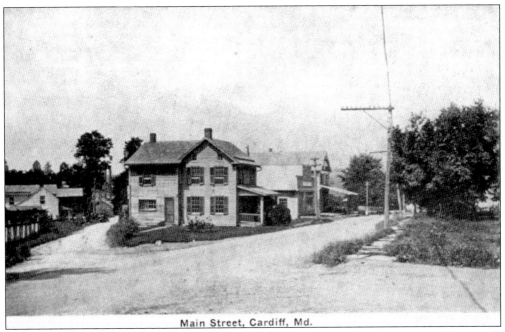

CARDIFF, MAIN STREET. Cardiff takes its name from the capital of Wales. Many of the town's ancestors came from Wales in the mid-1800s to mine the slate found in the slate ridge that runs from there to the Delta area. (Courtesy the Historical Society of Harford County, Inc.)

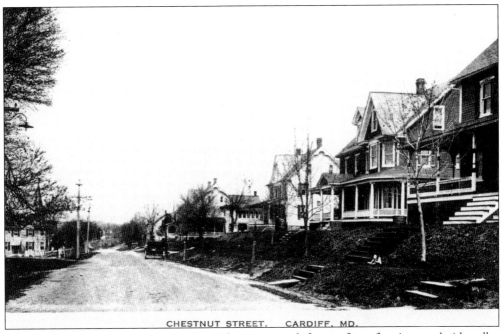

CARDIFF, CHESTNUT STREET, 1920. Slate was used for roofing, flooring, and sidewalks. Harford's slate was world famous. The constant demand for slate continued until the 1920s, when other cheaper and more plentiful materials were in use. (Courtesy the Historical Society of Harford County, Inc.)

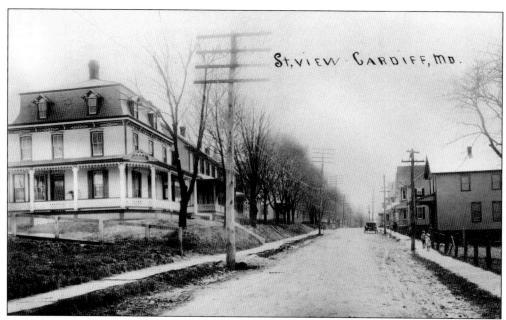

CARDIFF, STREET VIEW. Green marble was also found in one area of the mined hills—not real marble but a veined stone that resembled it. It was used in a number of government buildings in Washington. (Courtesy Marlene Herculson.)

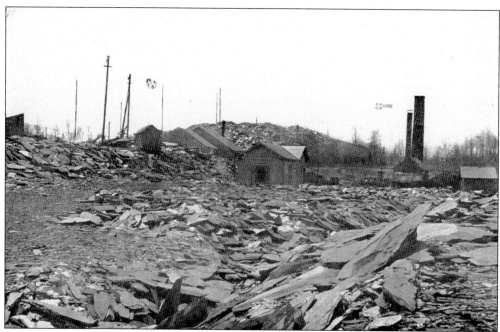

CARDIFF, SLATE FIELD. The slate was processed for different purposes depending on its quality. It could be sliced to different sizes and widths. (Courtesy the Historical Society of Harford County, Inc.)

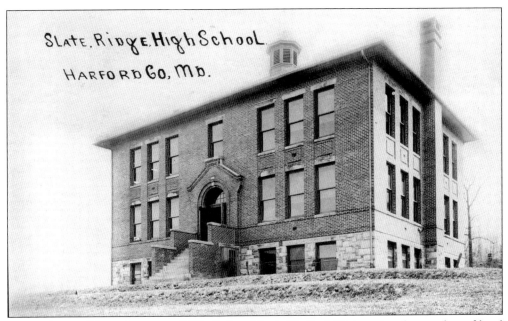

SLATE RIDGE HIGH SCHOOL, 1917. Before North Harford High replaced a number of local high schools, the aptly named Slate Ridge High educated the children of the Cardiff-Whiteford area. (Courtesy the Historical Society of Harford County, Inc.)

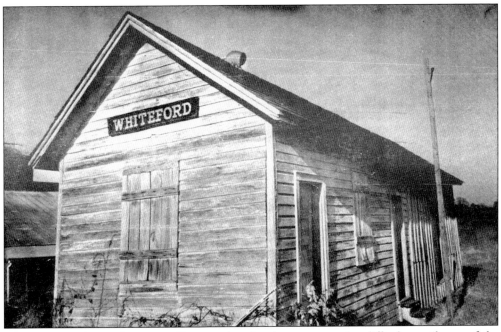

WHITEFORD TRAIN STATION. Transporting the slate was a major difficulty until one of the quarry owners managed to help create the Delta and Maryland Railroad Line. (Courtesy the Historical Society of Harford County, Inc.)

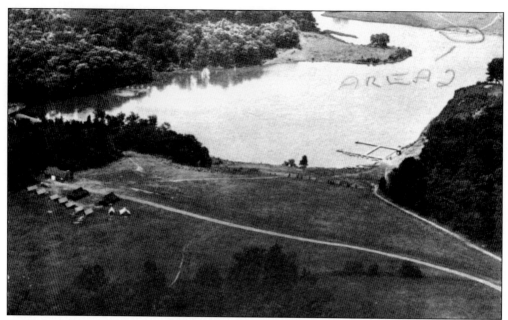

BROAD CREEK BOY SCOUT CAMP. Far from the center of Whiteford lies the Broad Creek Camp. For generations, Broad Creek has been the main campground for Boy Scouts in the tri-state area. (Courtesy the Historical Society of Harford County, Inc.)

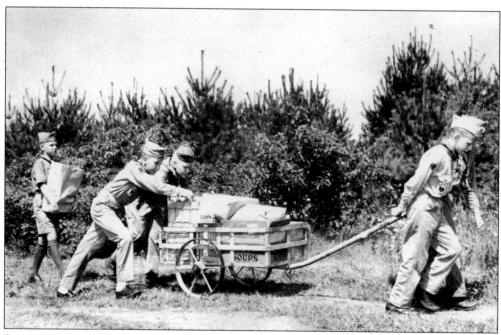

BOY SCOUTS AT BROAD CREEK CAMP. Broad Creek has it all for scouts: proximity to the water for swimming, water sports, and canoeing; long trails along the Susquehanna and up hills to build endurance; and plenty of wide open space for games and other activities. (Courtesy the Historical Society of Harford County, Inc.)

Two
DARLINGTON, BERKLEY, AND DUBLIN

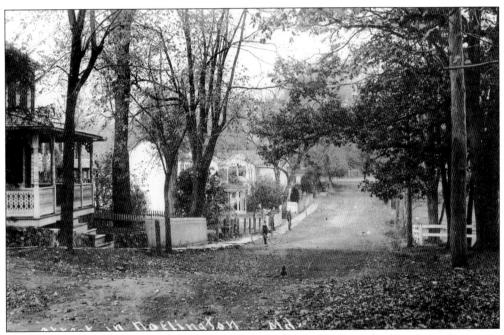

DARLINGTON, STREET VIEW. This image is from Shuresville Road looking west. A note on back says the card dates from before 1910. Many of the lovely stone Darlington homes, built during the early 1800s, still stand, and even today a little imagination can change the macadam road to dirt for a glimpse of yesteryear. Here the road slopes down, men stand by hitching posts, and there is a gas lamp and a boy with a bicycle. (Courtesy the Historical Society of Harford County, Inc.)

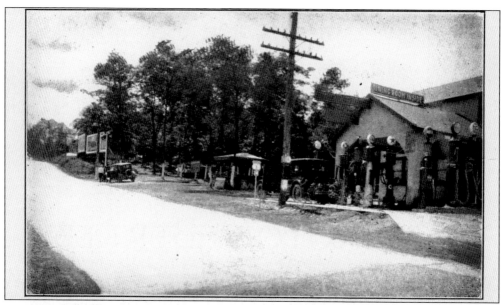

HOME COMFORT INN AND CAMP GROUND. Lodging was once plentiful throughout Harford County. Along frequently traveled roads and at major crossroads, travelers and their horses could get a night's rest at a hotel with stable. Later, motorists found campgrounds and then cottages along Route 1. Route 40 later became famous for its motels. Now exits off I-95 are dotted with hotels. (Courtesy the Historical Society of Harford County, Inc.)

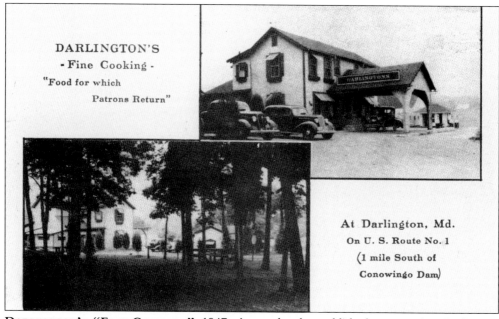

DARLINGTON'S "FINE COOKING," 1947. As an already established community, Darlington offered food and hospitality to the flow of travelers when Route 1 was the major byway. After an influx of new residents in the 1940s and 1950s, and once Route 40 and then I-95 became the roads of choice, Darlington settled down and became a quiet community once again. (Courtesy the Historical Society of Harford County, Inc.)

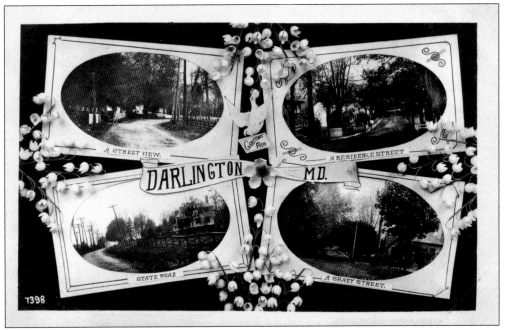

DARLINGTON, FOUR STREET VIEWS. Like four postcards in one, the views of Darlington on this card are marked: A Street View, A Residence Street, State Road, and A Shady Street. (Courtesy the Historical Society of Harford County, Inc.)

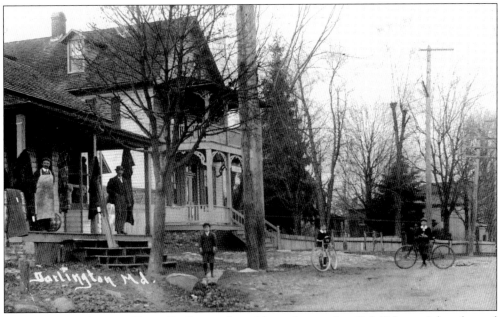

DARLINGTON, STREET VIEW. Darlington has a history longer than Bel Air's, yet it has changed little over the years. The Darlington Country Store, for example, has been through several incarnations in its more than 150 years of existence, actually starting as an inn. Yet the town retains the appearance of yesteryear. Strict development limitations keep the small town small, which is how Darlington likes it. (Courtesy Joan Nugent.)

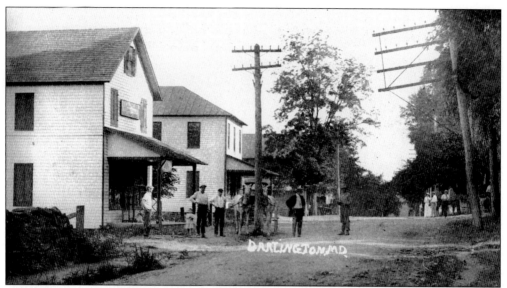

DARLINGTON, MAIN STREET. Lots of folks in a variety of outfits have gathered outside of J.T. Hopkins General Merchandise and elsewhere on Main Street to give a good cross-section picture of Darlington residents. Notice the blurry little girl who couldn't keep still for the exposure time, proof that photography wasn't candid in those days. (Courtesy the Historical Society of Harford County, Inc.)

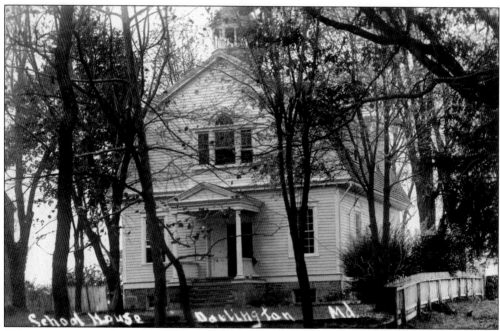

DARLINGTON SCHOOL HOUSE, 1911. To his wife in Baltimore, the sender wrote: "Will not be able to get home today, as all the people have gone away today and expect to go to town tomorrow, so I will go down in the morning with them. Have such bum[?] mails up here that you will not get this until tomorrow. Lovingly." (Courtesy the Historical Society of Harford County, Inc.)

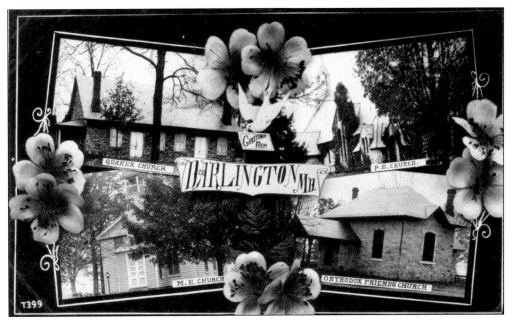

DARLINGTON, FOUR CHURCHES. Another four-in-one card shows places of worship: the Quaker Meeting House, M.E. Church, P.E. Church, and Orthodox Friends Meeting House. (Courtesy the Historical Society of Harford County, Inc.)

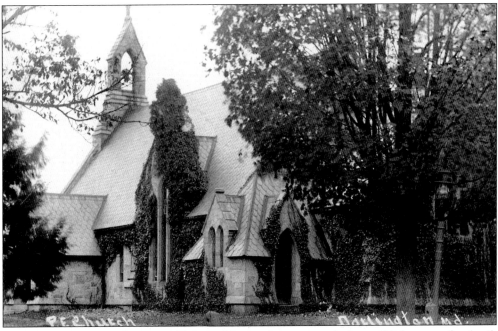

P.E. CHURCH. Grace Protestant Episcopal is seen in an unusual photo. With an eye for detail, the photographer has included a gaslight (to the right) and, instead of a head-on shot of the church, he's exploring the slopes and angles of the building, from steeple to roof to the cluster of slopes over the door and windows at the back. (Courtesy the Historical Society of Harford County, Inc.)

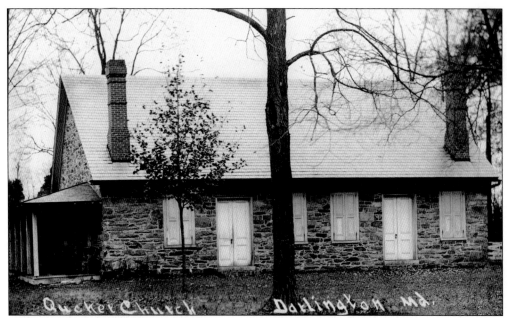

FRIENDS MEETING HOUSE. Looking for religious tolerance, Quakers settled early in the New World. Maryland especially had a reputation early on as a tolerant area. We'll see photo postcards of meeting houses in Forest Hill and Fallston, as well as this one in Darlington. (Courtesy the Historical Society of Harford County, Inc.)

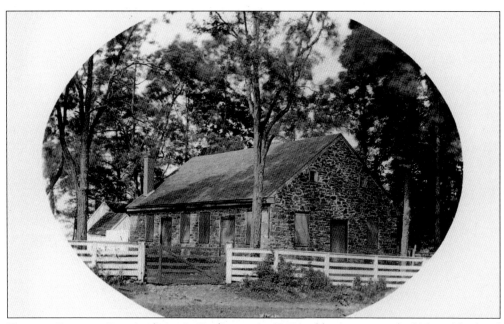

TRAPPE CHURCH. Imagine living in Darlington in 1760 and having to get the kids and husband ready to be at church on time in Perryman. So Spesutia Church in St. George's Parish in Perryman encouraged their folks up north to build the church pictured here—the Chapel of Ease. This is the third building to be so called. (Courtesy the Historical Society of Harford County, Inc.)

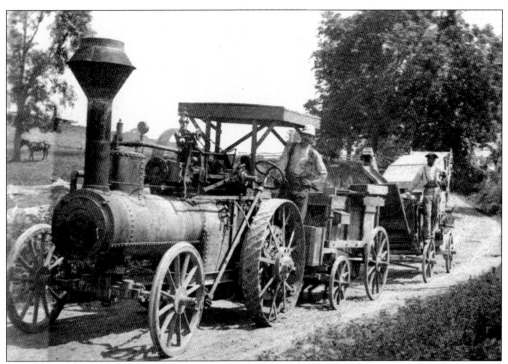

TRACTOR IN FIELD. This steam-driven tractor looks like a locomotive and pulls several carts behind it like a train. The farmer has invested in new technology, and it appears to be paying off for him. (Courtesy the Historical Society of Harford County, Inc.)

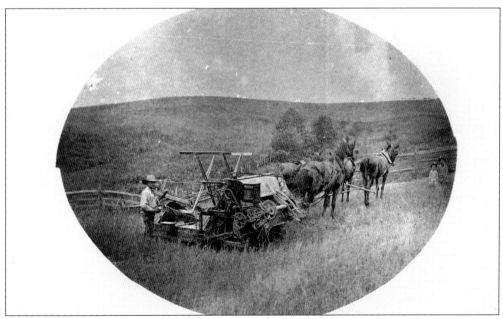

FARMER PLOWING FIELD. The horses are pulling, but the machine, probably another steam-driven beast like the tractor above, is doing the real work. (Courtesy the Historical Society of Harford County, Inc.)

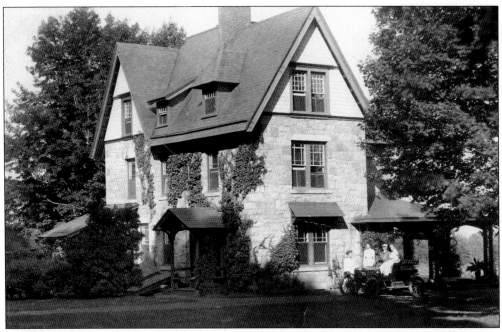

FAMILY IN CAR IN FRONT OF HOME. Many areas of the county can boast of fine homes, yet most of the homes in Darlington have been used as dwellings since they were built. By contrast, many historic homes in Bel Air and Havre de Grace have been turned into offices or bed and breakfasts. (Courtesy the Historical Society of Harford County, Inc.)

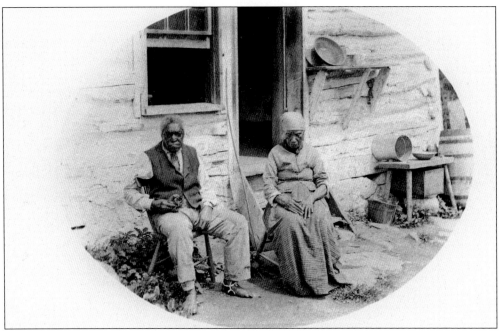

COUPLE IN FRONT OF HOME. This portrait of a couple is very close-up and intimate in feeling. The woman looks down, her hands spread out in her lap. There is a quiet dignity about the couple. (Courtesy the Historical Society of Harford County, Inc.)

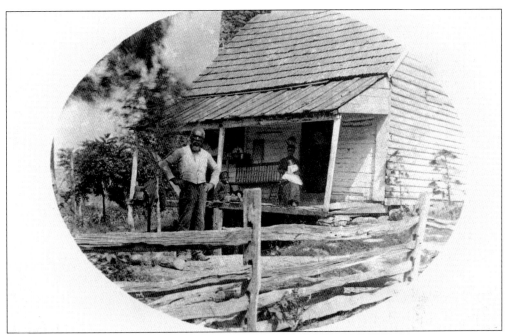

FAMILY AT HOME. Because of tolerant Quaker settlers early on, the Darlington-Berkley area has had a racially tolerant history. Free blacks settled in the area and were landowners long before emancipation. It is likely that this family owned their home and farm. (Courtesy the Historical Society of Harford County, Inc.)

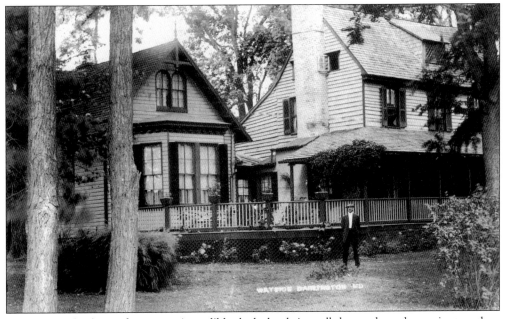

WAYSIDE. This home features an incredible deck that brings all the nooks and crannies together. (Courtesy the Historical Society of Harford County, Inc.)

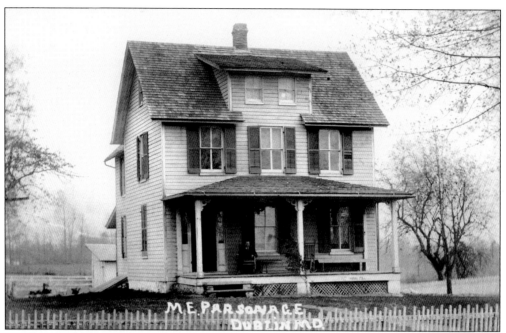

DUBLIN, M.E. PARSONAGE, 1915. The Methodist Episcopal church at Dublin was built around 1800 and rebuilt in 1860. This would have been the parsonage for that church. The church was replaced in 1939. (Courtesy the Historical Society of Harford County, Inc.)

BERKLEY, CROSSROADS. The crossroads of Berkley has seen many travelers on the way to Conowingo. A sign for Conowingo Bridge is on the pole at the right of the photo. The general store and post office stands to the left with owner Charles Andrew on the porch. He kept the store going until 1918. (Courtesy the Historical Society of Harford County, Inc.)

Three
ALONG THE SUSQUEHANNA

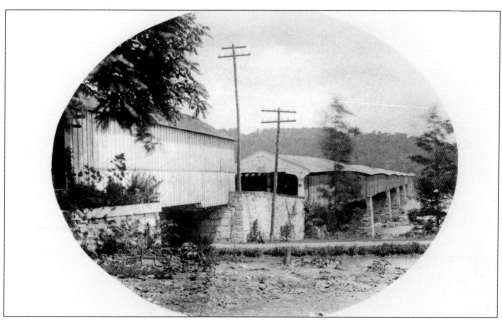

COVERED BRIDGE OVER SUSQUEHANNA RIVER. The great things about a big river are fish, transportation, and feeder streams providing water for mills and irrigation for crops. The challenge presented by a big river is getting across. Ferries worked when passengers were few and cargoes were small. All the founding fathers—Washington, Jefferson, and the rest—went through Harford and over the Susquehanna by ferry. But as the nation grew, a reliable system of transporting goods and increasing numbers of people over the river was needed. This covered bridge was the first solution. (Courtesy the Historical Society of Harford County, Inc.)

FLINT MILL AT STAFFORD(SHIRE), 1933. The sender wrote: "This is a picture of remains of the old Staffordshire Flint Mill. . . . The region around Stafford is a picture of desolation. Nothing there but brambles, underbrush, thickets, pole cats and snakes." Into the 1920s, the flint, mined and then melted and crushed into powder, was sent to Trenton, New Jersey, to make porcelain and pottery. (Courtesy the Historical Society of Harford County, Inc.)

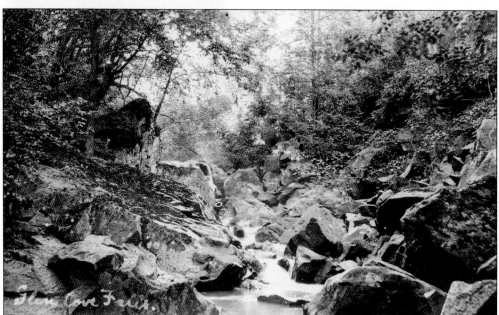

FALLS AT GLEN COVE. Glen Cove was the location of one of the locks for the Tidewater Canal. It's also where Peddlers Run spilled out into the Susquehanna. The area was flooded by the creation of the dam in 1927. (Courtesy the Historical Society of Harford County, Inc.)

TOWPATH TEA HOUSE. The canal towpath was a memory when this restaurant served travelers along Route 1 from 1920 to 1926 with fresh chicken and other Maryland dishes. (Courtesy the Historical Society of Harford County, Inc.)

TOWPATH TEA HOUSE. Visitors to the Tea House included President Warren Harding and his wife in 1921. Sen. Millard Tydings was a regular. A casualty of the dam, the Tea House was torn down in preparation for the dam's construction. (Courtesy the Historical Society of Harford County, Inc.)

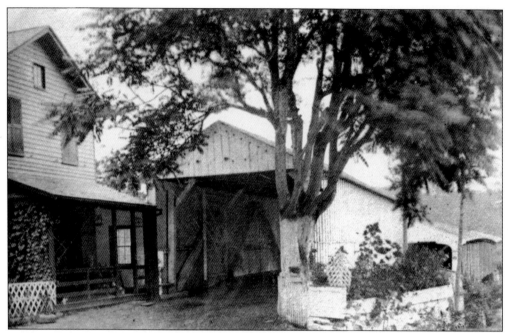

BRIDGE TOLL HOUSE. Like many wooden bridges of the period, the Conowingo Bridge was covered. Of course, that made it doubly susceptible to fire from lightning and the ravages of winds. The bridge keeper lived at the toll house and collected a toll from bridge crossers. (Courtesy the Historical Society of Harford County, Inc.)

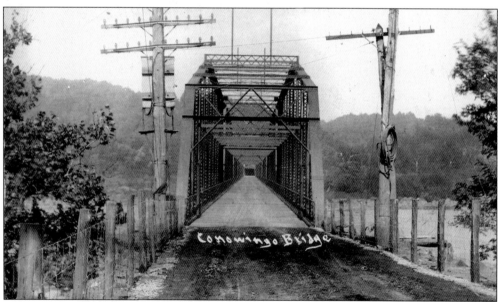

CONOWINGO BRIDGE, 1910. In 1907, much of the wooden bridge burned and section by section was replaced by iron. The black rectangle in the center is a covered section of the bridge. This bridge stayed in service until the dam opened in 1927. No longer needed, the iron bridge was blown up with nitroglycerin and an electric charge. Its remains lie underwater. (Courtesy Joan Nugent.)

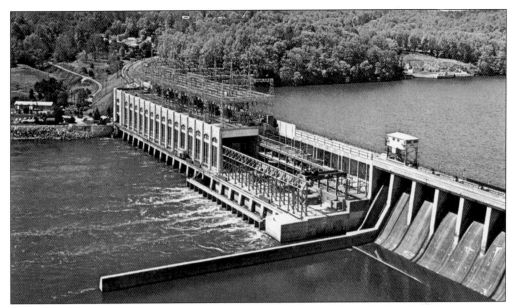

CONOWINGO DAM. Opened on November 19, 1927, the Conowingo Dam changed the way of life around the Susquehanna forever. As the waters of the Susquehanna collected on one side of the huge concrete wall, old towns, mines, and banks were covered with water. On the other side, the floods and ice floes were now controlled by technology. This photo was taken after additional turbines were added in the late 1950s. (Author's collection.)

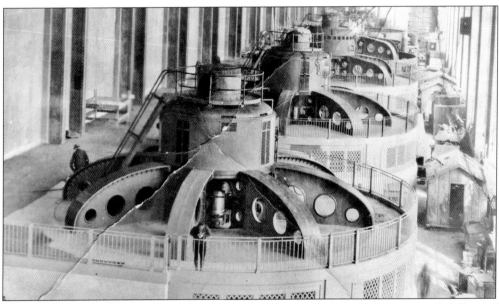

CONOWINGO DAM TURBINES. This is a simple idea on a grand scale: the controlled flow of water turns wheels, which generate electricity, which powers machines that do work. Not so different from the water wheels on mills along streams all over Harford County, except that they directly powered the grinding stones. Size matters: in the 1950s, the dam supplied power to 10–15 percent of then-owner Philly Electric's customers. (Courtesy the Historical Society of Harford County, Inc.)

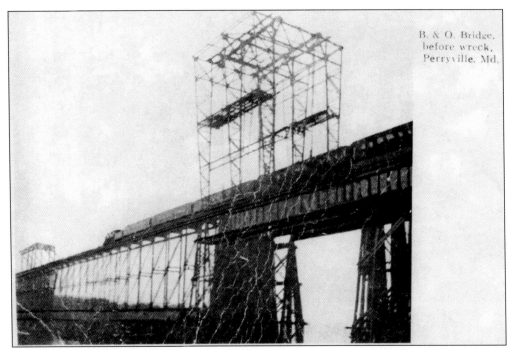

B&O Bridge before Wreck. This wrinkled old postcard shows the Baltimore and Ohio Railroad bridge that linked Havre de Grace and Perryville. Like many of the bridges spanning the river, portions rested on islands in the Susquehanna. (Courtesy James R. Bierer.)

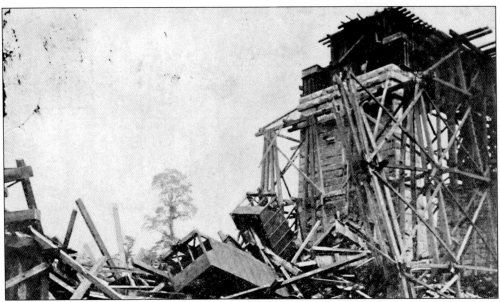

East End of B&O Bridge over Susquehanna River Showing Wreck. On September 23, 1908, the bridge's first span, 337 feet long, between Garrett Island and the Cecil County side, collapsed. The crossing locomotive pulling the train stayed on track, but 12 coal cars fell into the opening. Despite the wreckage, only one person was hurt; no one died. (Courtesy James R. Bierer.)

Four
Havre de Grace

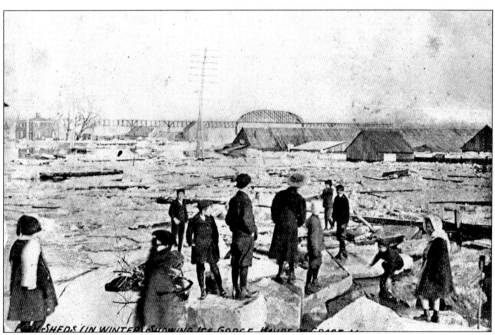

Fish Sheds in Winter Showing Ice Gorge. The port city of Havre de Grace sits where the Susquehanna River empties into the Chesapeake Bay. The riches of the sea and sky were legendary. Fishing wasn't just a pastime; it was a major industry. The fish sheds stayed in the river and processed huge nets full of fish—half a million in one catch. During the fishing season, the men worked, slept, and ate on the sheds. (Courtesy the Historical Society of Harford County, Inc.)

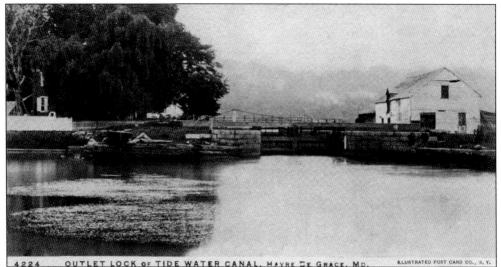

OUTLET LOCK OF TIDEWATER CANAL. Because of the unpredictable waters of the Susquehanna, the Tidewater Canal was built alongside it for the transportation of goods by boat. A series of locks ran along the canal, the most famous being the lock, with its lockhouse, at Havre de Grace. (Courtesy the Historical Society of Harford County, Inc.)

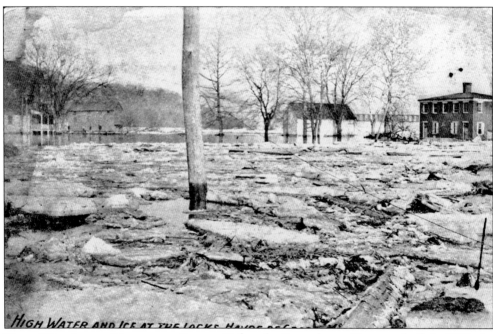

HIGH WATER AND ICE AT THE LOCKS. Before the Susquehanna Dam was built in 1927, the river was prone to flooding and freezing. This photo shows the same buildings as above but from behind—the flooding has pushed the frozen waters of the river up onto the land. (Courtesy the Historical Society of Harford County, Inc.)

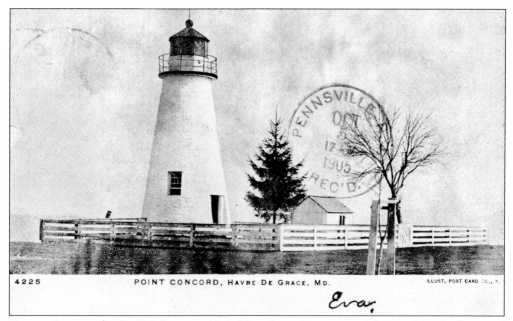

POINT CONCORD. The lighthouse guided ships along the coast at night. Poole's Island, part of the Aberdeen Proving Ground complex, has a sister lighthouse to Point Concord by the same builder. (Courtesy James R. Bierer.)

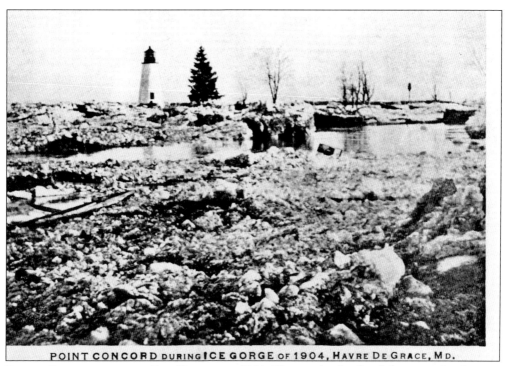

POINT CONCORD DURING ICE GORGE OF 1904. Here again, the floods have sent ice far onto the banks of the Havre de Grace shore. The Conowingo Dam would control the river, so flooding became less of a fear. (Courtesy Richard Tome.)

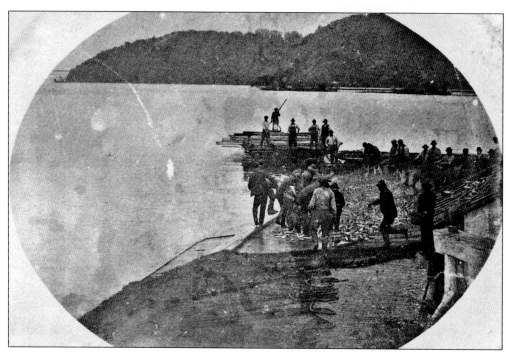

FISHING INDUSTRY ON SUSQUEHANNA. Here the workers drag fish from the seine onto the fish shed floor to begin processing. (Courtesy the Historical Society of Harford County, Inc.)

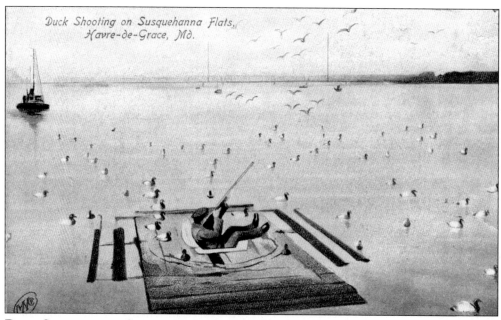

DUCK SHOOTING ON SUSQUEHANNA FLATS. The Flats are sandy deposits formed where the Susquehanna River flows into the Chesapeake Bay. They effectively make the 80-foot-deep waters only waist high in places. Legend has it that the ballplayer Babe Ruth liked to party out on the Flats. This card shows the hunter on the Flats surrounded by duck decoys. (Courtesy the Historical Society of Harford County, Inc.)

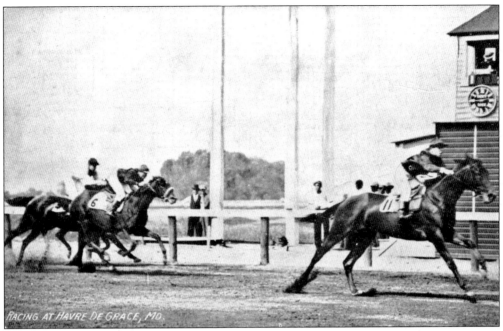

RACING AT HAVRE DE GRACE. This card gives a feeling for the excitement of the race with a close view of three horses, the tower, and people standing in the infield. Seabiscuit raced here. For about four weeks out of the year, from 1912 to 1950, the track attracted casual bettors and criminals alike. (Courtesy the Historical Society of Harford County, Inc.)

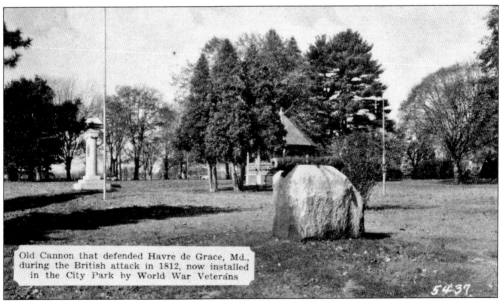

OLD CANNON IN CITY PARK. During the War of 1812, the British burned much of Havre de Grace. At their approach by sea, brave John O'Neill and a few men fired on them with small cannons. O'Neill was captured and later released as befitted a commissioned officer. He was made lighthouse keeper in 1829 as a reward. Five generations of O'Neills tended the light. (Courtesy James R. Bierer.)

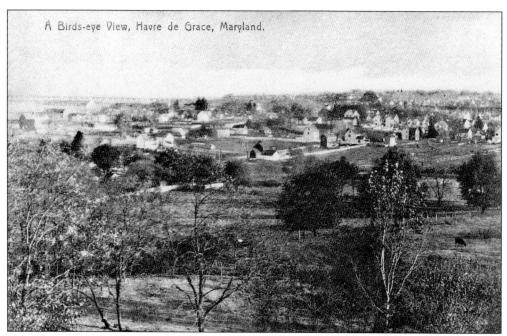

BIRD'S EYE VIEW, 1908. Until the increasing development in recent years, much of the farmland visible in this photo had remained farmland. (Courtesy the Historical Society of Harford County, Inc.)

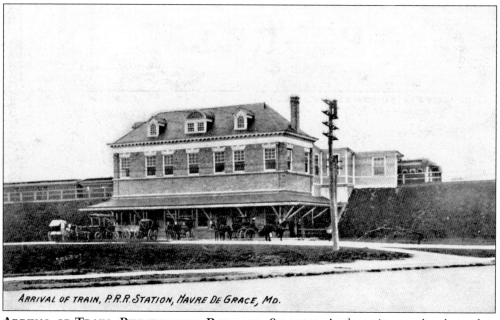

ARRIVAL OF TRAIN, PENNSYLVANIA RAILROAD STATION. As the train must be elevated to access the bridge over the Susquehanna, so the station has two levels to accommodate travelers. (Courtesy the Historical Society of Harford County, Inc.)

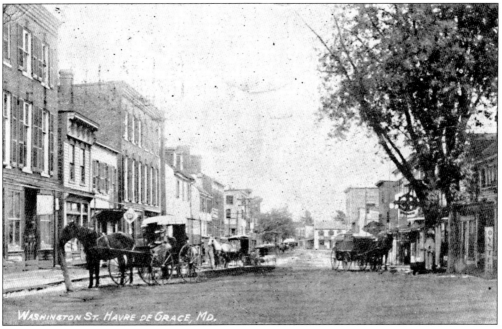

WASHINGTON STREET, 1912. This card may be a reprint of an earlier photograph, but the view is incredible. Pave the streets, replace horses with cars, and Washington Street still has that old-time feel today (minus the oysters). (Courtesy James R. Bierer.)

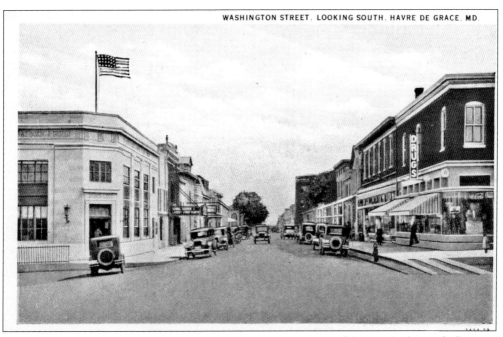

ST. JOHN STREET, LOOKING SOUTH. This commercial stretch of the city looks much the same today, with many of the original structures repurposed for new businesses. For example, the bank in the left foreground is currently a restaurant. (Courtesy the Historical Society of Harford County, Inc.)

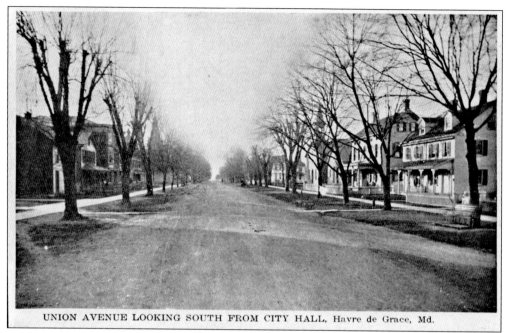

UNION AVENUE, LOOKING SOUTH FROM CITY HALL. Pictured here, mainly with residences and churches, this stretch of the city is mostly commercial today, although the tree-lined avenue still keeps a shadow of its quiet past. (Courtesy the Historical Society of Harford County, Inc.)

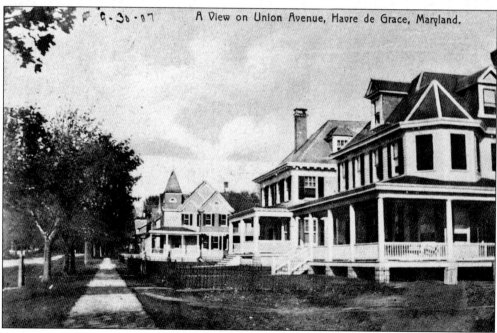

A VIEW ON UNION AVENUE, 1907. The town was originally laid out with broad streets. Union Avenue remains its heart. (Courtesy the Historical Society of Harford County, Inc.)

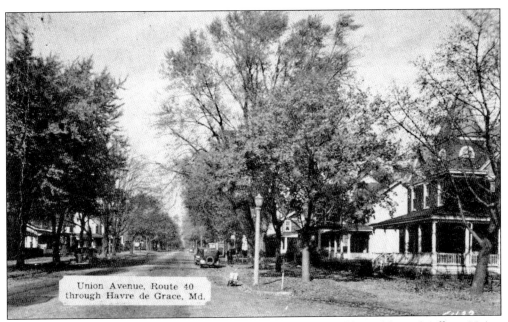

UNION AVENUE, ROUTE 40. With eateries, inns, the hospital, and lots of doctor's offices, Union Avenue is busy yet subdued. (Courtesy James R. Bierer.)

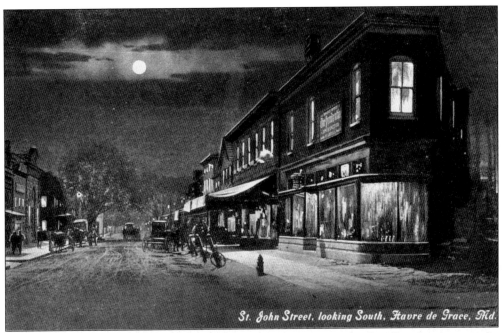

ST. JOHN STREET, LOOKING SOUTH, 1918. This card has a painterly effect that portrays the nighttime town life. With travelers by land and sea coming into town at all hours, many establishments stayed open all night. (Courtesy the Historical Society of Harford County, Inc.)

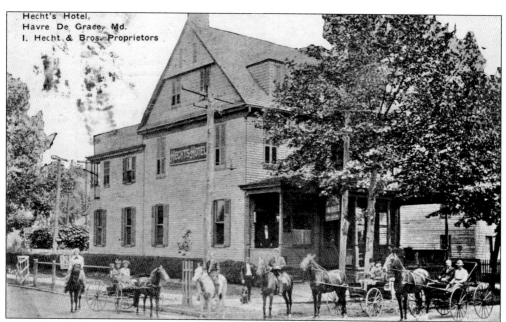

HECHT'S HOTEL, 1916. The optimistic sender wrote, "Stayed here last night—I just got up going to [?] this m[orn]ing only 80 miles. Had no trouble yet—all well." This looks like a scene from the Old West. Guests traveled by horse, with or without carriage. Servicing the horses was as important as giving tired travelers a place to stay. (Courtesy the Historical Society of Harford County, Inc.)

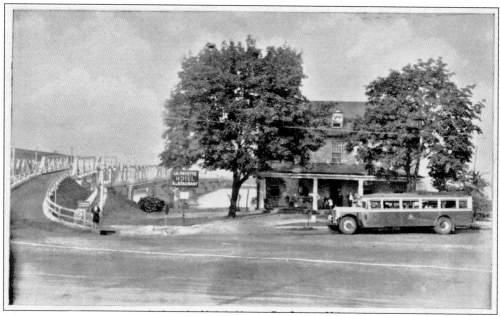

LAFAYETTE HOTEL. The back of the card reads, "On the Susquehanna River. Fishing, Boating, Ducking, Official P.R.T. Bus Depot." This blue-tinted card shows the Lafayette Hotel (today it is the American Legion hall) with the bus in front and the entry to the bridge going to Perryville. (Courtesy the Historical Society of Harford County, Inc.)

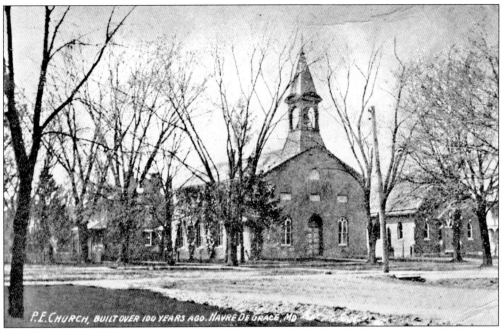

P.E. Church, Built Over 100 Years Ago, 1910. There is lots of wide open space, but where did people keep their horses during services? (Courtesy the Historical Society of Harford County, Inc.)

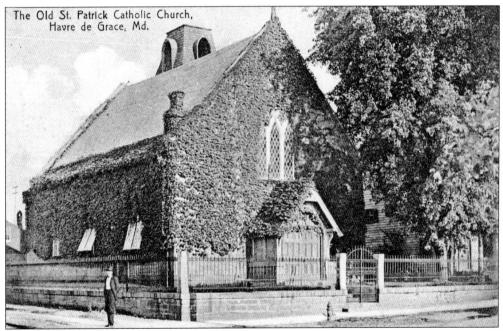

Old St. Patrick Catholic Church, 1912. Today we know that ivy is bad for the façade of a building, but the Victorian sensibility of Havre de Grace at the turn of the century required ivy, ivy, and more ivy. (Courtesy the Historical Society of Harford County, Inc.)

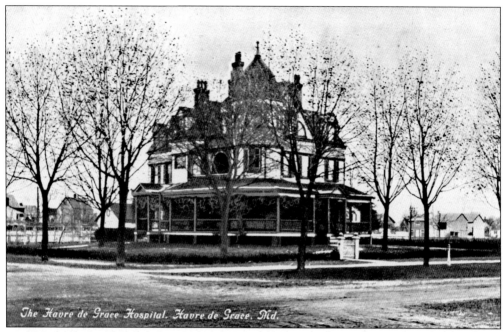

HAVRE DE GRACE HOSPITAL. From 1912 to 1944, this building was the hospital for most of the surrounding communities. The wraparound porch must have allowed for outdoor convalescing in or out of the sun, depending on which side of the building patients sat. (Courtesy the Historical Society of Harford County, Inc.)

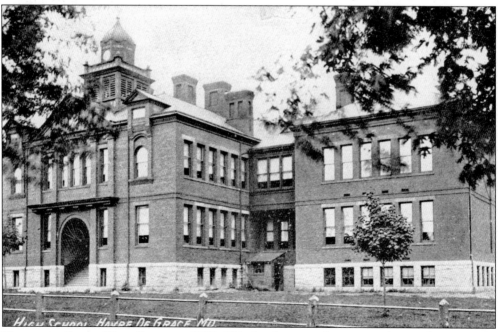

HAVRE DE GRACE HIGH SCHOOL, 1907. This shot is repeated on postcards over the years. The trees get taller. This is one of the earliest versions, which must have been taken close to the school's opening in 1896. (Courtesy the Historical Society of Harford County, Inc.)

Five
ABERDEEN AND APG

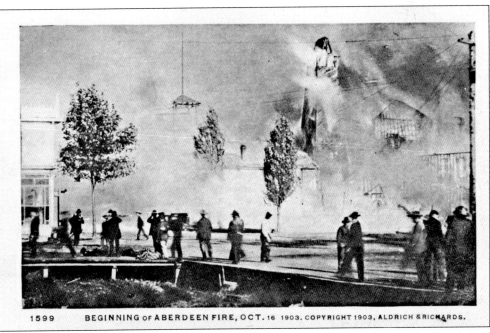

BEGINNING OF ABERDEEN FIRE, OCTOBER 16, 1903. As this rare card shows, Aberdeen joined other towns in the first years of the new century with devastating fires. But nothing would change Aberdeen like the creation of Aberdeen Proving Ground (APG). In the months before the end of World War I, the U.S. Army, by presidential order, took possession of over 69,000 acres and over 100 miles of waterfront along the west shore of the Chesapeake Bay to form a weapons training and testing facility, replacing its 1874 facility at Sandy Hook, New Jersey. Postcards record the changes in the conditions and activities at the Ordnance Training Center, Edgewood Arsenal, and Aberdeen Proving Ground. (Courtesy the Historical Society of Harford County, Inc.)

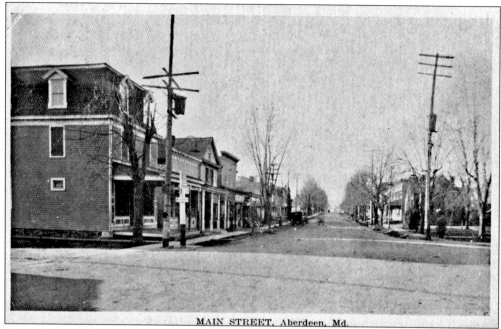

MAIN STREET. Modern Aberdeen owes much of its early prosperity to the genius of George Washington Baker, the father of canning. The surrounding farmland, including the land that would become APG, was corn, pea, and tomato country. Baker's invention of automated canning spawned over 180 canneries in Harford County and made Baker rich—and he shared his riches with the city. (Courtesy James R. Bierer.)

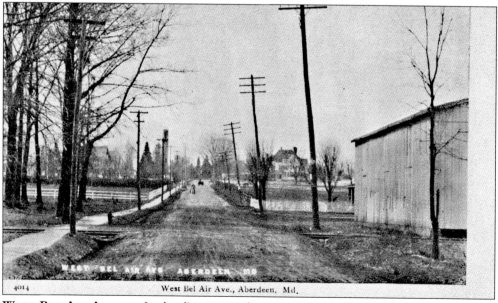

WEST BEL AIR AVENUE. In the distance on the upper left side of the street is the standpipe, which created pressure to carry water delivered to homes through pipes under Bel Air Avenue and side streets. Before they lost everything in the Depression, Baker and his five sons built huge homes, one of which is in the distance on the top right of this view. (Courtesy James R. Bierer.)

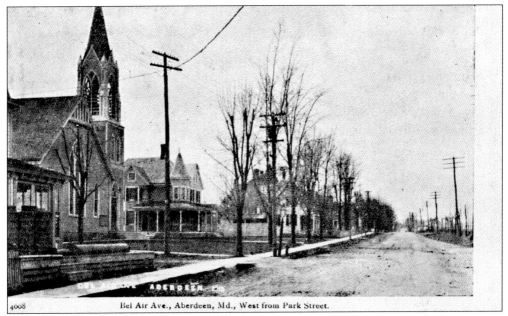

BEL AIR AVENUE, WEST FROM PARKE STREET. As good public citizens, the Bakers made improvements to the city: they built the Methodist church (seen here on the corner), donated land for Aberdeen Cemetery, built the first electrical station in town (it ran from 6–10 p.m. each evening), and put paving and water and sewer lines along West Bel Air Avenue. (Courtesy the Historical Society of Harford County, Inc.)

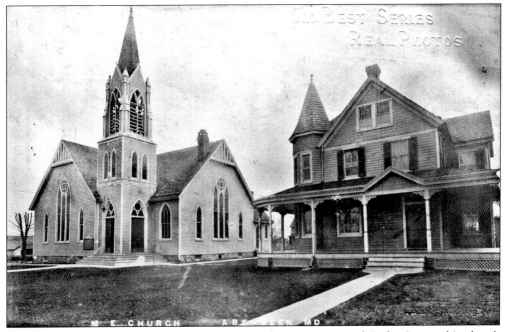

ABERDEEN M.E. CHURCH. Built in 1893 at Bel Air Avenue and Parke Street, this church replaced the original 1856 church on Broadway, making way for the 1908 high school. See the top of page 46 for the rest of the story. (Courtesy James R. Bierer.)

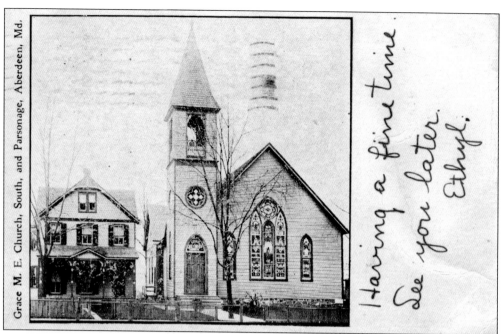

GRACE M.E. CHURCH, SOUTH, AND PARSONAGE, 1907. Southern sympathizers broke away from the Methodist church in 1866 and built this structure in 1899. Happily, the two congregations reunited in 1942 and built the Grace United Methodist Church. (Courtesy James R. Bierer.)

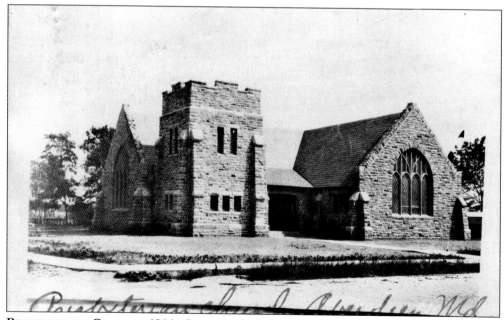

PRESBYTERIAN CHURCH, 1916. Grove Presbyterian Church began in 1854 when a group of the faithful met in a grove of trees, now the cemetery. When the congregation outgrew the original brick church, the new stone church pictured here was built in 1912 and has been added to over the years. (Courtesy James R. Bierer.)

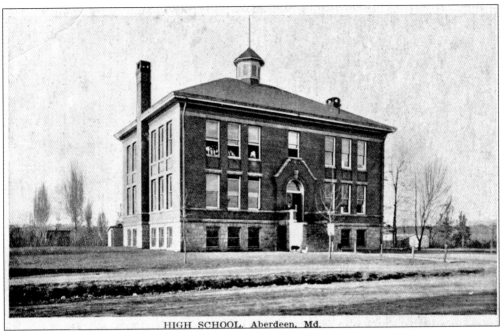

HIGH SCHOOL, Aberdeen, Md.

HIGH SCHOOL. After the Methodist congregation built its new church, the Broadway church lot was used for the new eight-room elementary and high school in 1908, seen here soon after its opening. Once APG opened, the need for an even larger school complex led to the building of the big school on Route 40 in 1935. (Courtesy the Historical Society of Harford County, Inc.)

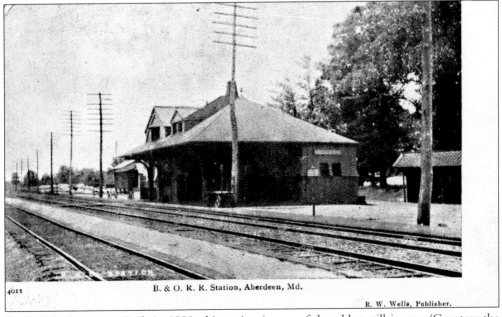

B. & O. R. R. Station, Aberdeen, Md.

R. W. Wells, Publisher.

B&O RR STATION. Built in 1880, this station is one of the oldest still in use. (Courtesy the Historical Society of Harford County, Inc.)

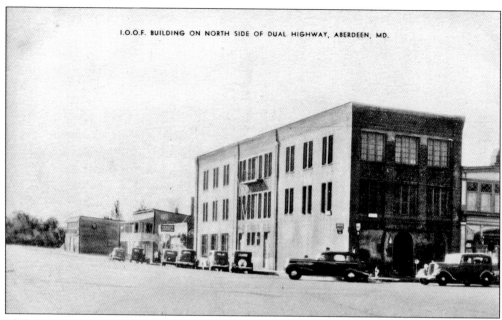

IOOF Building on North Side of Dual Highway. This is the original International Order of Odd Fellows building from 1893 on the corner of Route 40 and West Bel Air Avenue. Fires led to new buildings on the same spot in 1918 and 1976. (Courtesy the Historical Society of Harford County, Inc.

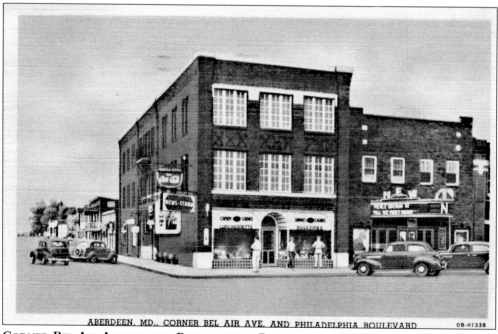

Corner Bel Air Avenue and Philadelphia Boulevard, 1943. The second Odd Fellows building is shown here. The New Theater is showing Merle Oberon in the 1940 film *Till We Meet Again.* (Courtesy Nancy M. Sheetz.)

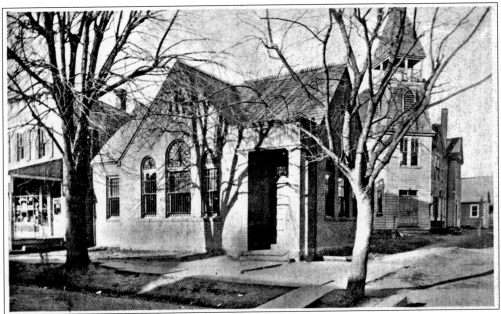

FIRST NATIONAL BANK. This is the original 1891 First National Bank of Aberdeen, on the corner of Howard Street and West Bel Air Avenue. In 1919, a new building was literally built around the first. (Courtesy the Historical Society of Harford County, Inc.)

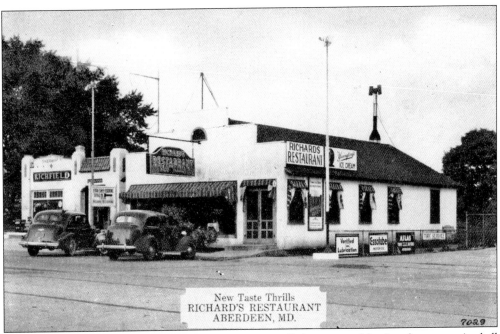

RICHARD'S RESTAURANT. As we've seen, motoring, dining out, and having the car serviced all went together in the 1930s and 1940s, thus all of the auto service signs. Notice a sign for Yuengling Ice Cream. It turns out the Yuengling family that owns the oldest brewery in the United States (in Pottsville, Pennsylvania) also owned Yuengling Ice Cream. (Courtesy the Historical Society of Harford County, Inc.)

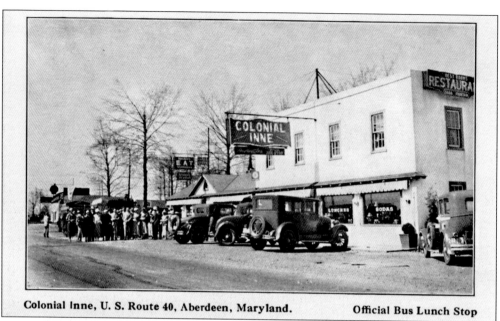

Colonial Inne, U. S. Route 40, Aberdeen, Maryland. **Official Bus Lunch Stop**

COLONIAL INNE, U.S. ROUTE 40. Fine restaurants have been part of the Aberdeen scene for years. Population growth in Aberdeen, first from the booming canning industry beginning in the 1870s and then from the influx of military and civilian support personnel to APG, meant steady growth in the service industry as well—hotels, motels, service stations, and restaurants. (Courtesy the Historical Society of Harford County, Inc.)

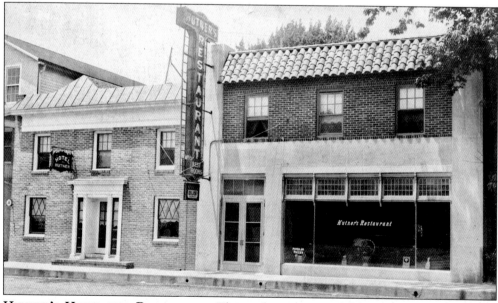

HUNTER'S HOTEL AND RESTAURANT. The service economy in Aberdeen got another boost when the state made the decision in 1935 to bypass improvements to the Post Road in favor of the new dual-lane highway known as Pulaski Highway or Route 40. By 1937, motorists were taking in the joys of driving the open highways. (Courtesy the Historical Society of Harford County, Inc.)

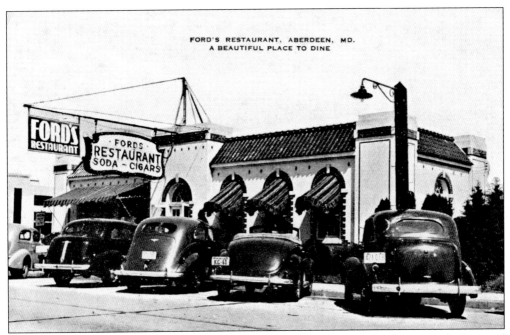

FORD'S RESTAURANT. Not coincidentally, the local postcard industry became reinvigorated with the opening of Route 40. New motels and restaurants turned to the picture postcard, sometimes tinted in lurid pastels, to attract customers and offer a souvenir of their stay. (Courtesy the Historical Society of Harford County, Inc.)

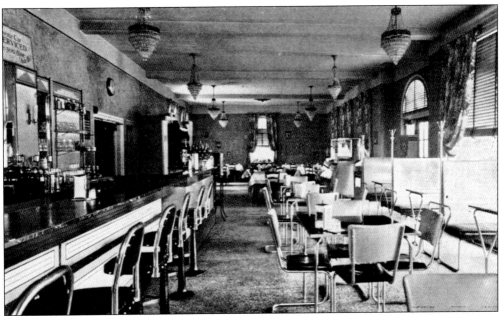

RESTAURANT, INTERIOR. Early photography depended on daylight or studio powder flashes for sufficient lighting of subjects. After the 1927 invention of the modern flash bulb by General Electric, photographers could more easily and quickly shoot hard-to-light interiors, as seen here. (Courtesy the Historical Society of Harford County, Inc.)

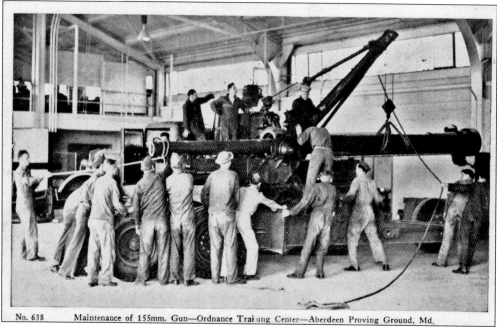

No. 638, Maintenance of 155 mm Gun, Ordnance Training Center, 1943. As APG was, and is, an army base dedicated to weapons development, testing, and training, one of the duties of the men was to keep the ordnance in tip-top shape, as shown in this nicely composed photo, one in a series showing duties on base. (Courtesy the Historical Society of Harford County, Inc.)

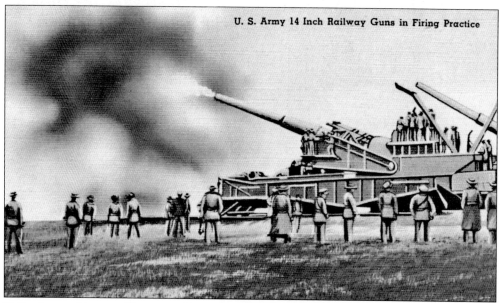

U.S. Army 14-inch Railway Guns in Firing Practice, APG. Susan Walter, whose family lived far away on Howard Street in Bel Air, recalls the noise from weapons training and testing at APG that would shake the ground and make dishes rattle. (Courtesy the Historical Society of Harford County, Inc.)

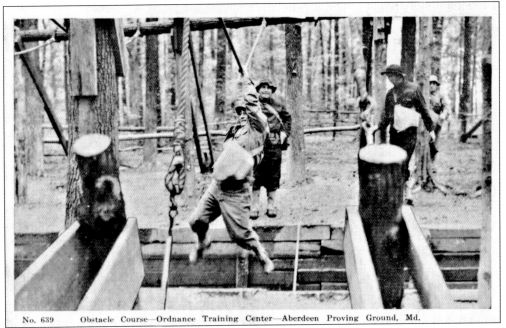

No. 639 Obstacle Course—Ordnance Training Center—Aberdeen Proving Ground, Md.

OBSTACLE COURSE, ORDNANCE TRAINING CENTER, APG. As Harford County's largest employer since World War I, APG today employs around 6,700 civilian and 4,800 military personnel. (Courtesy the Historical Society of Harford County, Inc.)

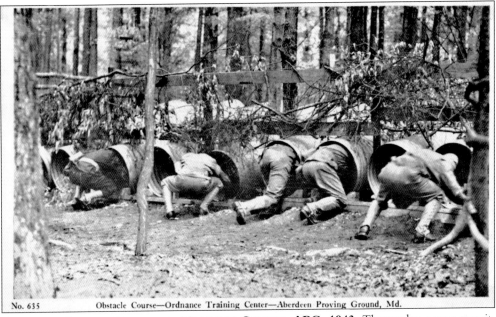

No. 635 Obstacle Course—Ordnance Training Center—Aberdeen Proving Ground, Md.

OBSTACLE COURSE, ORDNANCE TRAINING CENTER, APG, 1943. The sender, a new recruit, writes, "Just a line to let you know I haven't forgotten you. This Army life is a busy life, especially the first few weeks at least. Do you know yet what your future is concerning the Army. My guess is that you would prefer the Govt. depot." (Courtesy the Historical Society of Harford County, Inc.)

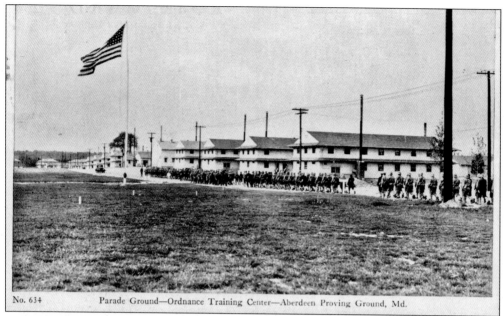

No. 634 Parade Ground—Ordnance Training Center—Aberdeen Proving Ground, Md.

NO. 634 PARADE GROUND, ORDNANCE TRAINING CENTER, 1943. Although no longer in use, the barracks in this view still stand as a testimony to the large numbers of men trained and stationed at APG during World War II. (Courtesy the Historical Society of Harford County, Inc.)

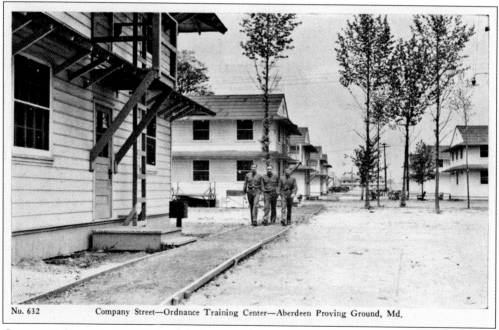

No. 632 Company Street—Ordnance Training Center—Aberdeen Proving Ground, Md.

COMPANY STREET, ORDNANCE TRAINING CENTER, APG, 1943. A private writes home to Ohio: "Dear Ma, Did a big washing Friday night wish you could have been here to help. Old fashioned scrub board. Front is exact picture of platoon I & 64 other fellows live in. Helped build a boat house all day. Weather is terrible here about 15 degrees in morning & about 55 in afternoon & mud every place."(Courtesy the Historical Society of Harford County, Inc.)

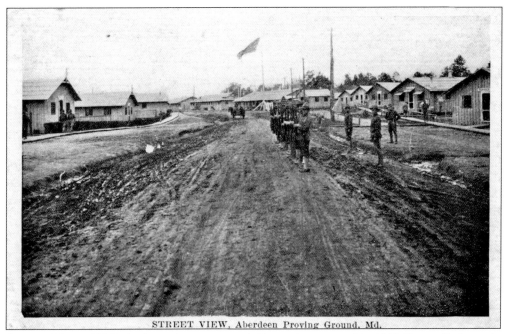

STREET VIEW, APG. As the main county road, Route 1 was paved in 1918. Route 7, the main road to Edgewood Arsenal, was not much better than the street in this photo taken during World War I and had to wait several more years for public funding to be paved. (Courtesy the Historical Society of Harford County, Inc.)

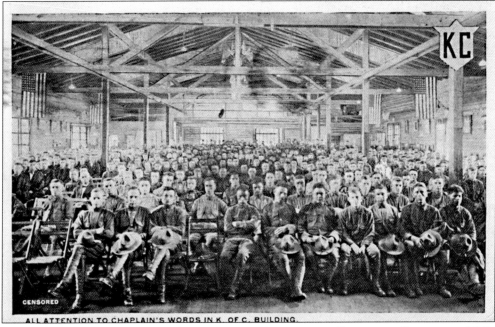

ALL ATTENTION TO CHAPLAIN'S WORDS IN KNIGHTS OF COLUMBUS BUILDING, APG. Another World War I–era photo is shown here. (Courtesy the Historical Society of Harford County, Inc.)

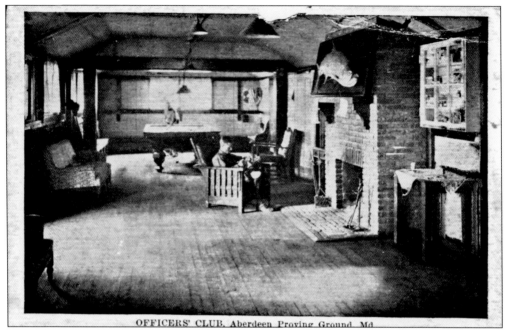

OFFICERS' CLUB, APG. This World War I photo is not at all what the movies lead you to expect from an officers' club. (Courtesy the Historical Society of Harford County, Inc.)

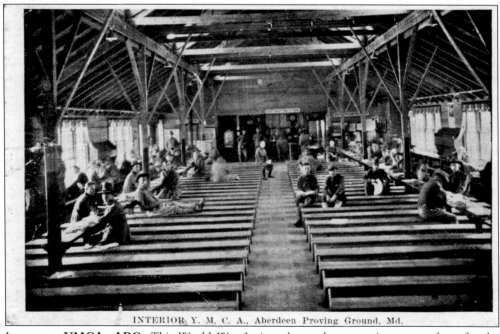

INTERIOR YMCA, APG. This World War I view shows the entertainment on base for the troops. (Courtesy the Historical Society of Harford County, Inc.)

Six
ORIGINAL HARFORD

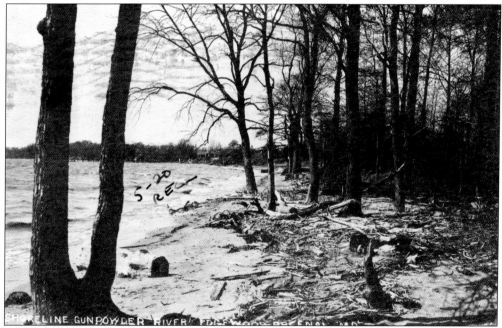

SHORELINE, GUNPOWDER RIVER, EDGEWOOD ARSENAL. Even before heightened security following September 11, 2001, most of the APG and Edgewood Arsenal property had become lost to Harford residents—at least to those who did not work on base. There are many reasons for that loss—national security, unexploded ordnance, and chemical weapons storage. It isn't the kind of place where you would walk around even if you were allowed. That is why postcards such as this rare one are so important: they remind us of the beauty that still exists, albeit now on government-owned land. (Courtesy the Historical Society of Harford County, Inc.)

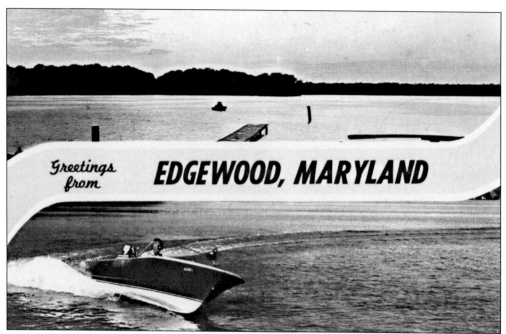

GREETINGS FROM EDGEWOOD. Water brought the first English explorers and settlers to Harford's shores. Edgewood's water and waterfront properties have been rediscovered in recent years, but they've always been one of the main attractions of pleasant living in Harford County. (Author's collection.)

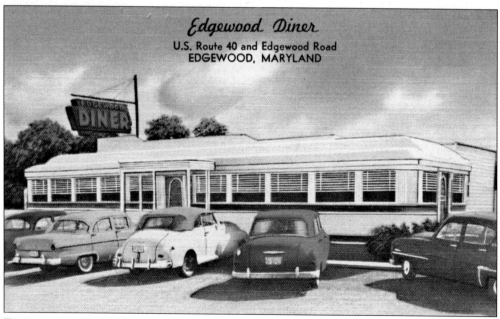

EDGEWOOD DINER. The diner has given way to fast food joints, but the diner, while good for a quick meal, was about catching up with folks you knew, reading the paper at the counter, and giving strangers the once-over from your booth in the corner. (Courtesy the Historical Society of Harford County, Inc.)

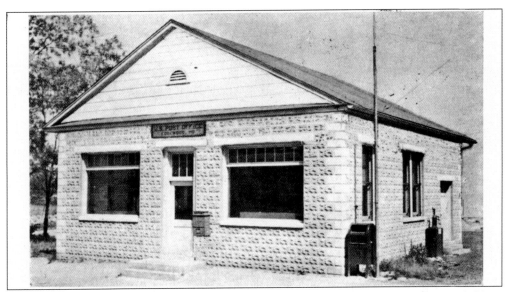

U.S. POST OFFICE, EDGEWOOD, 1943. In this poignant message, the sender, probably a military wife, writes to her son and daughter-in-law: "Well, how do you like our P.O. Some town. But I think these little houses out here look pretty. All white with different colored roofs. They need rain. Just as you do. The weather is about the same." (Courtesy the Historical Society of Harford County, Inc.)

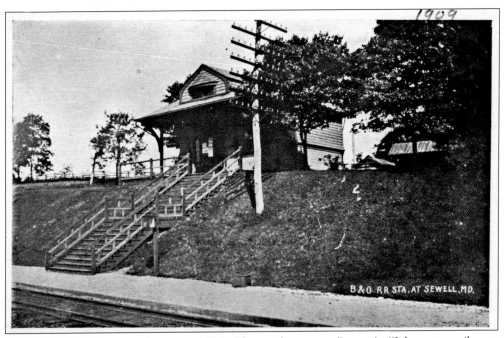

B&O RR STATION AT SEWELL, 1909. The sender wrote (in part): "I have to smile out loud when I look at this station, for it makes me think of Rosa Knight and her traveling costume.... Heard you yelling out the window to the ice man." Of course, block ice, delivered daily, kept the icebox cold before electric refrigeration. (Courtesy the Historical Society of Harford County, Inc.)

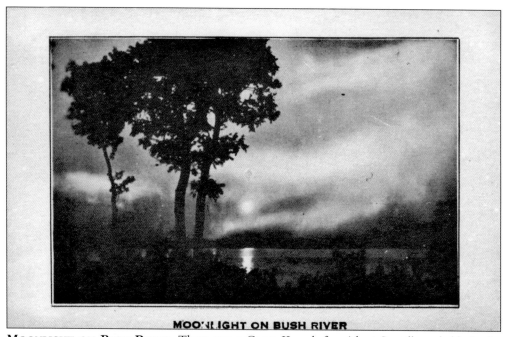

MOONLIGHT ON BUSH RIVER. There was a Camp Kemah for girls at Sewell, probably in the 1920s. A series of postcards shows the various camp buildings, but no girls or activities. (Courtesy the Historical Society of Harford County, Inc.)

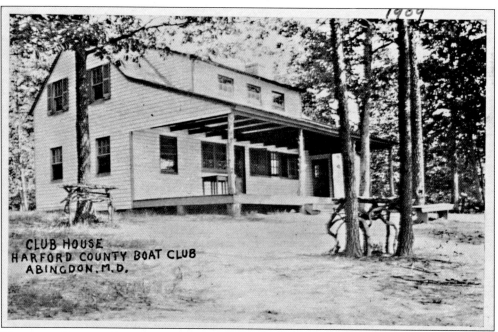

HARFORD COUNTY BOAT CLUB, ABINGDON, 1909. The writer says, "You don't care for this card but its all I have of the bunch at present writing, will send more as I get them. Am just a little flushed this morning. Shot is fall think and fast. Hope I don't get it in de neck. Au revoir." The postmark is from Aberdeen. (Courtesy the Historical Society of Harford County, Inc.)

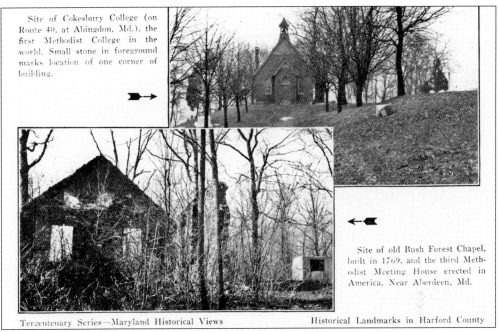

TERCENTENARY SERIES, COKESBURY COLLEGE, BUSH FOREST CHAPEL SITE. The Tercentenary Series of postcards was produced in 1934 to celebrate the 300th anniversary of the landing of the ships the *Ark* and the *Dove*, which brought some 200 settlers from England to Maryland's shores. (Courtesy the Historical Society of Harford County, Inc.)

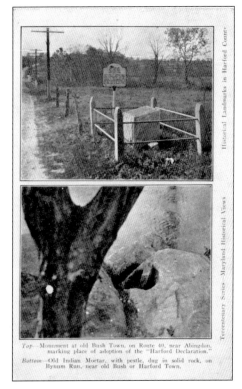

TERCENTENARY SERIES, HARFORD DECLARATION. The value of this 1934 postcard series is more than educational: it was the only time a concentrated effort was made to compile a photographic record of the sites, buildings, and artifacts important in the founding years of the state. It is the last view of many of these places, lost to time and land development. (Courtesy the Historical Society of Harford County, Inc.)

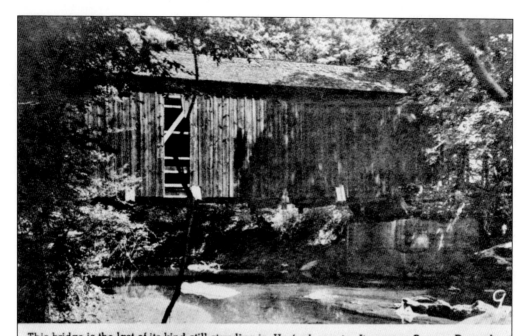

This bridge is the last of its kind still standing in Harford county. It crosses Bynum Run, about a mile down the Hookers Mill road from Bush. It may date back to the 1850's or 60's

HOOKERS MILL COVERED BRIDGE. At one time, most bridges were covered. Harford County is now home to only one covered bridge—the one at Jerusalem Mill. (Courtesy James R. Bierer.)

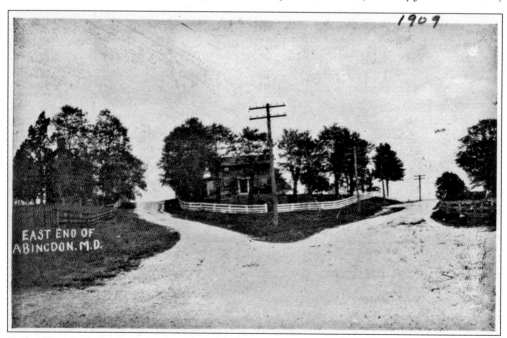

EAST END OF ABINGDON ROAD, 1909. Pretty spare for a postcard image, this view of Abingdon is nothing if not honest. According to Thirza Brandt, the right hand side of the fork in the road is Route 7, also called Philadelphia Road. (Courtesy the Historical Society of Harford County, Inc.)

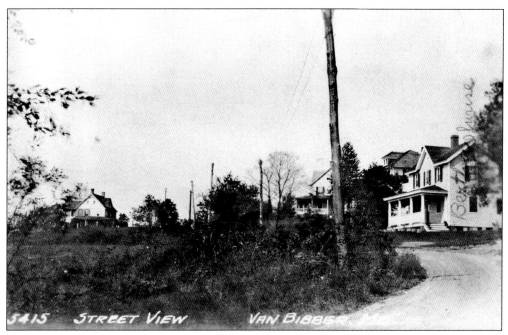

STREET VIEW, VAN BIBBER, 1913. Explaining life in Van Bibber, this card reads, "We arrived at cousin's about half after nine and had a fine trip. We are going to Baltimore tomorrow Bertha said you should come down do not forget. From Edna, Bertha, & Irene. The first house is Bertha's." (Courtesy the Historical Society of Harford County, Inc.)

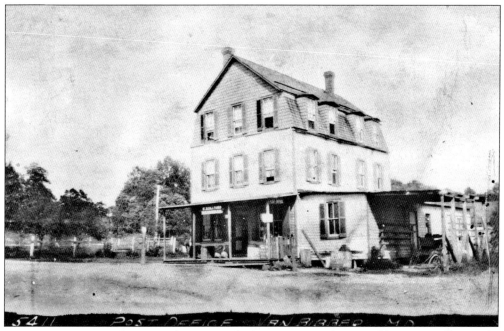

POST OFFICE, VAN BIBBER. The sign reads, "W. Benj. Ford, Van Bibber Post Office." The card above (Bertha's house) has a postmark from the Van Bibber post office. (Courtesy the Historical Society of Harford County, Inc.)

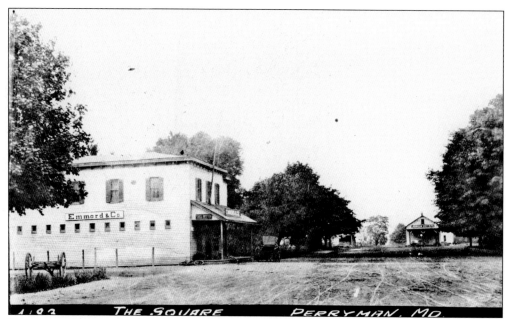

THE SQUARE, PERRYMAN, 1913. On June 1, 1913, the sender writes, "I am in this store eating ice cream." The store is Emmord & Co. Store, owned by J.H. Emmord. The post office is in the store. The Johnson Brothers, Otho and William, whose store is on the right, have a piece of farm equipment outside. They sold other things the farm community needed—fertilizer, lumber, and other supplies. (Courtesy Mary L. Martin Ltd.)

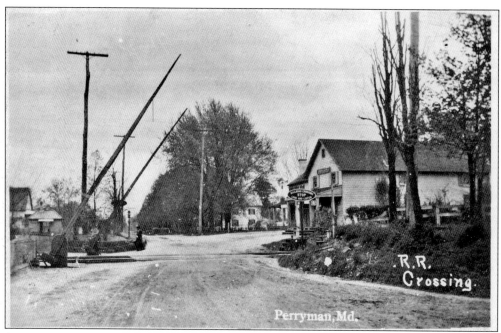

RAILROAD CROSSING, PERRYMAN, 1909. The railroad accounted for the success that the canning industry had in Perryman, where thousands of cases of corn and other vegetables could be shipped easily to Baltimore. (Courtesy the Historical Society of Harford County, Inc.)

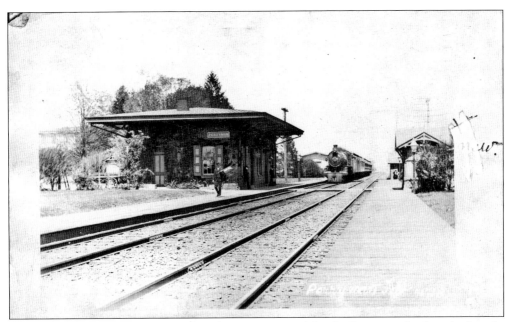

TRAIN STATION, PERRYMAN, 1910. The town is named for the Perryman family, who bought a large chunk of Cranberry Hall, the name given to the original tract of land. After the railroad came and the town developed, the town was called Perrymansville for a while, but that took too long to say or write, so they shortened it to Perryman. (Courtesy the Historical Society of Harford County, Inc.)

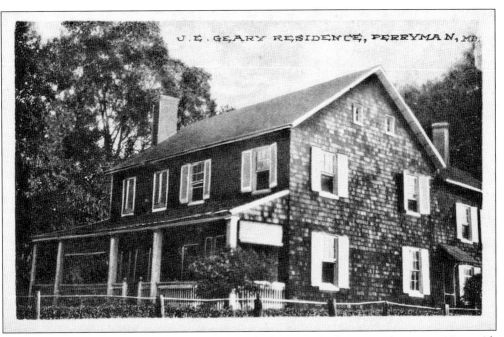

J.E. GEARY RESIDENCE, PERRYMAN. Geary had a store in Perryman in competition with Emmord. His home is made to seem all the more imposing by the photographer's unique style. (Courtesy the Historical Society of Harford County, Inc.)

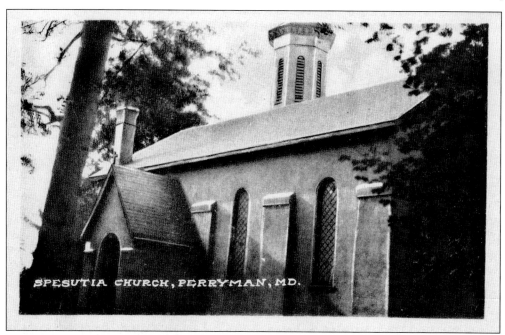

SPESUTIA CHURCH, PERRYMAN. As with the Geary residence, the photographer uses a monumental style that works especially well with the Norman architecture of Spesutia Church. (Courtesy the Historical Society of Harford County, Inc.)

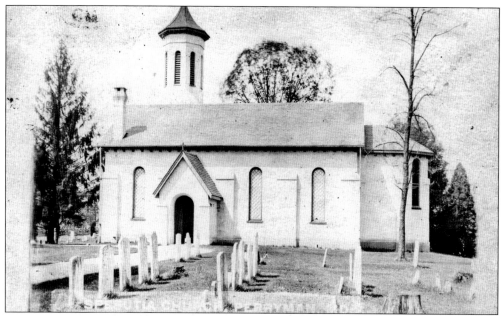

SPESUTIA CHURCH, PERRYMAN, 1908. The sun is shining fully on this, the fourth church building, and its gravestones as it has on St. George's Parish since 1671, making St. George's the oldest parish in the county. This 1851 building one of Harford's oldest churches still in use. (Courtesy the Historical Society of Harford County, Inc.)

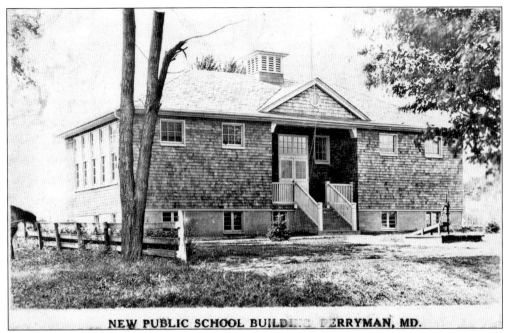

NEW PUBLIC SCHOOL BUILDING, PERRYMAN. Note the water pump in the front yard. A horse is tied at the fence. In a time when walking miles to school was accepted practice, riding a horse must have been a luxury. Come to think of it, that's probably the principal's parking spot. (Courtesy the Historical Society of Harford County, Inc.)

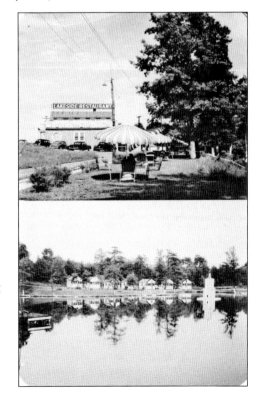

LAKESIDE RESTAURANT, JOPPA. A slice of life from Joppa in 1909, this postcard says: "I went to Bel Air with Hail[?] yesterday morning he wanted to get his shoes mended and Cleo shod, and late in the afternoon I took the chickens away. I am going to make chili sauce and catsup today. I have some fine tomatoes John brought them yesterday morning." (Author's collection.)

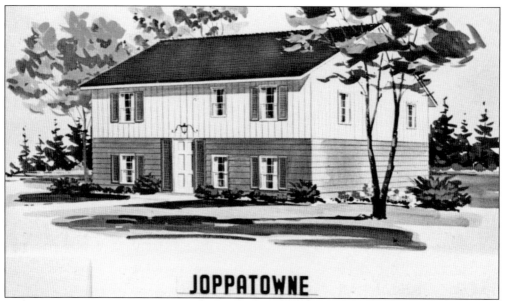

JOPPATOWNE MODEL HOME. The back reads: "JOPPATOWNE, the new, totally planned residential community . . . custom built atmosphere achieved through unique design . . . 12 models to choose from such as this 4 bedroom, TWO-STORY Colonial Model. . . . Prices range from $8,990 (as low as $79.48 a month) to $12,990 plus $120 G.R. Located off Route 40 just North of the Baltimore County Line in Harford County." (Courtesy the Historical Society of Harford County, Inc.)

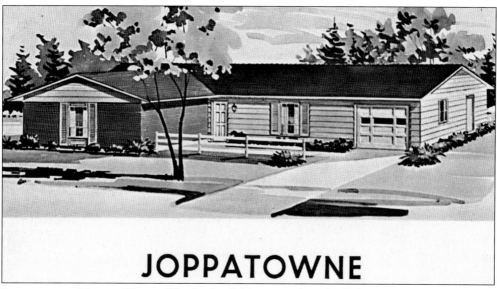

JOPPATOWNE MODEL HOME. The back of this postcard reads: "The L-RANCHER model, COLONIAL style . . . located at JOPPATOWNE, a new and totally-planned community offering five basic model houses available in 24 different exterior styles or colors. The houses sell from approximately $9,000 to $13,000 plus $120 G.R. JOPPATOWNE borders on the scenic Gunpowder River. From Baltimore drive east on Pulaski Highway approximately 8 miles beyond Martin Blvd." (Courtesy the Historical Society of Harford County, Inc.)

Seven
BEL AIR, CHURCHVILLE, AND LEVEL

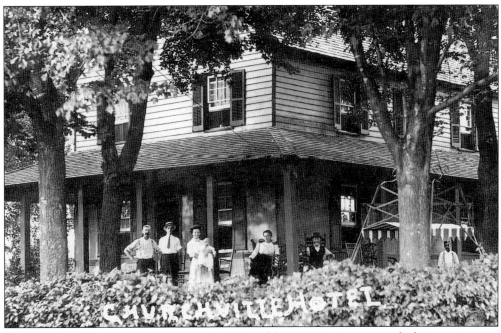

CHURCHVILLE HOTEL. Churchville sat in an enviable position: at a crossroads that went west to Bel Air, north to Dublin, south to Creswell and Harford Furnace, and east to Havre de Grace and Aberdeen. What a great place for a hotel, seen in this rare photo. (Courtesy Walter G. Coale, Inc.)

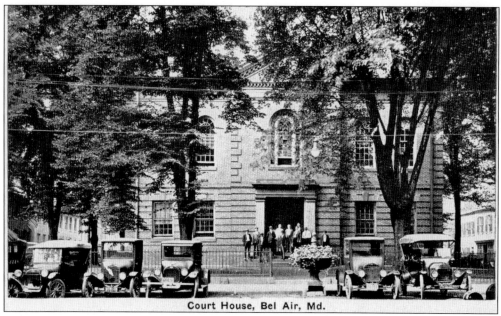

COURT HOUSE, FRONT VIEW, BEL AIR. This photo marks a paradigm shift. The original function of the fountain was to water horses. Here the fountain is filled with flowers like a giant planter. The horses are gone, the auto has become the dominant mode of transportation, and the fountain has become a decorative item. (Courtesy James E. Kropp.)

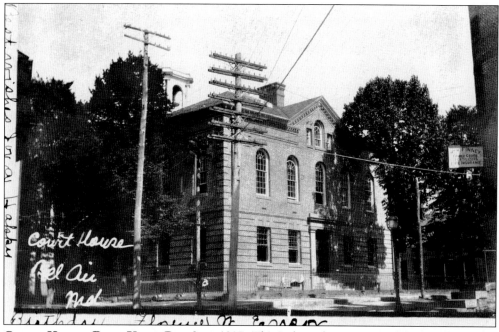

COURT HOUSE, REAR VIEW, BEL AIR, 1907. This is the only rear view of the courthouse the author has seen. Many cards show the front. To the right is the tower column of the Masonic Temple with a sign for "Wm. W. Finney, Canned Goods, Fertilizer, Fire Insurance." (Courtesy James R. Bierer.)

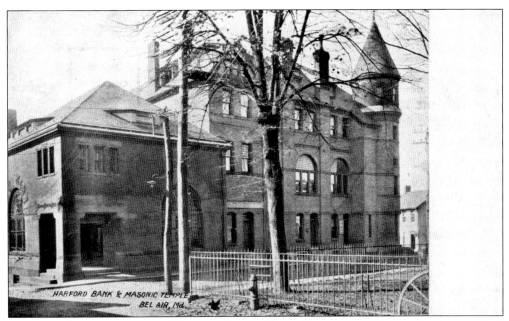

HARFORD BANK & MASONIC TEMPLE, FRONT VIEW, BEL AIR, 1909. Usually photographed from the tower side, the bank is in the foreground here, which lends it a little more weight and balance. The street between the courthouse and the bank is Wall Street, destroyed in 1980 when the bank and temple were torn down to expand the courthouse back to Bond Street. (Courtesy Nancy M. Sheetz.)

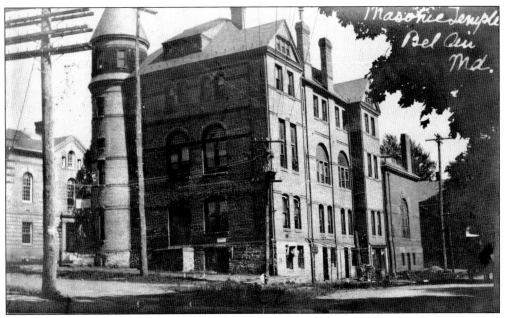

MASONIC TEMPLE, REAR VIEW, BEL AIR, 1906. This card reveals another rare view. Most folks who can remember the Masonic Temple remember the restaurant that was built into the back of it. Here there are shop entrances into the basement. One sign reads Lyle's, while the sign at the side of the building says Ladies Entrance. (Courtesy James R. Bierer.)

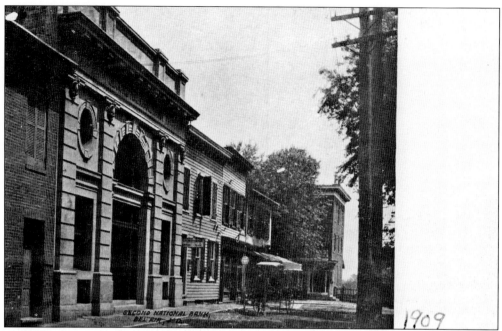

SECOND NATIONAL BANK, OFFICE STREET, BEL AIR. This is one of the few buildings that began as a bank and has remained a bank, though the names have changed greatly. Today it is M&T Bank. (Courtesy James R. Bierer.)

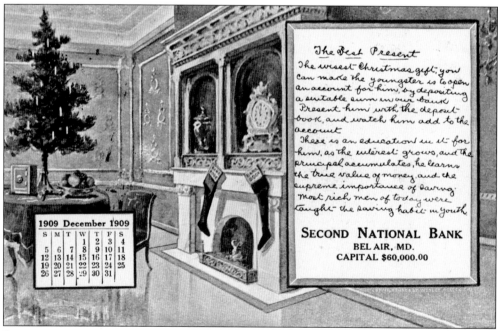

SECOND NATIONAL BANK CALENDAR POSTCARD, DECEMBER, 1909. Different banks in the county used cards similar to these. The helpful messages, as here, encouraged good habits, such as putting money in a savings account. The little calendar made it a keeper. (Courtesy the Historical Society of Harford County, Inc.)

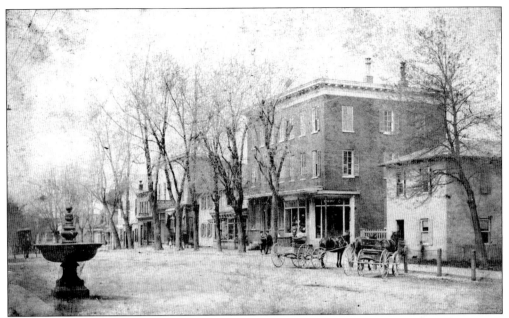

COURT HOUSE SQUARE, BEL AIR, 1906. This is an amazing eye-level view of Main Street goings-on. Two shop names are mostly visible: Ewing & Co. on the corner door of the Vaughn Hotel and Evans Bros. Druggists, where Boyd & Fulford would be just a few years after. Next to that is the post office. The three boys, right of center, are priceless. (Courtesy James R. Bierer.)

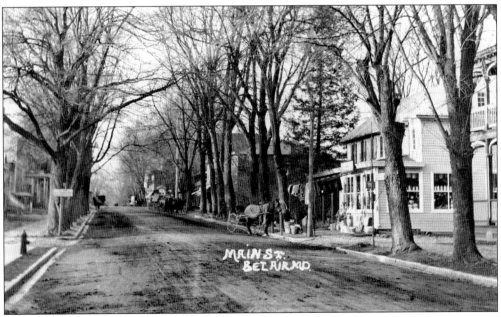

SOUTH MAIN STREET AND BALTIMORE ROAD, BEL AIR. The sign on the store to the right where the horse is hitched says General Hardware. It may also have the name Boarman on it. Boarman's Hardware took over the Granger Hotel building. The business eventually became known as Courtland Hardware. Blankets, fireplace tools, and other necessaries are displayed outside the doorway. (Courtesy James R. Bierer.)

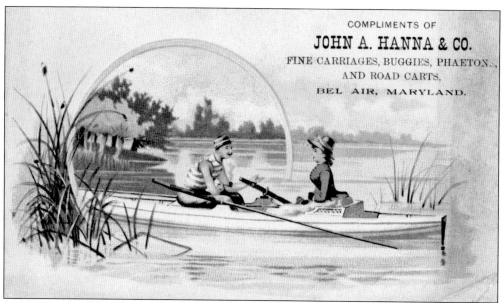

JOHN A. HANNA & COMPANY ADVERTISING POSTCARD. This card reads: "Any style of Carriage or Sleigh Furnished. Branch House at Aberdeen, Md., in Charge of T.L. Hanway. Write for Prices." There is no date on the card, but we do know that Bel Air had a buggy factory capable of making 3,000 buggies a year, which burned in 1891 after just three years of operation. (Courtesy the Historical Society of Harford County, Inc.)

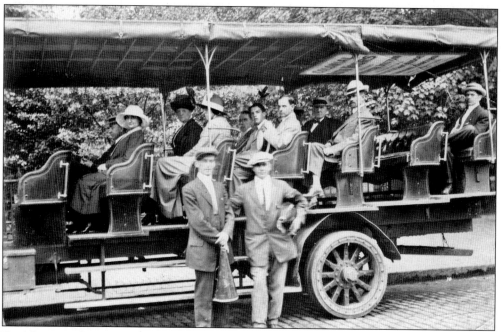

BEL AIR TO CARNEY BUS. In 1913, service began using a Packard bus to take riders down winding Harford Road to Carney to meet the streetcar lines that would connect to all points in Baltimore. (Courtesy the Historical Society of Harford County, Inc.)

GRANGER'S HOTEL, SOUTH MAIN STREET, BEL AIR. Bel Air was a town full of hotels and inns. A note from a 1910 card from the Kenmore Inn says, "We ate so many hot buscits and fried chicken that we had to walk around 2 hours to dijist it." (Courtesy James R. Bierer.)

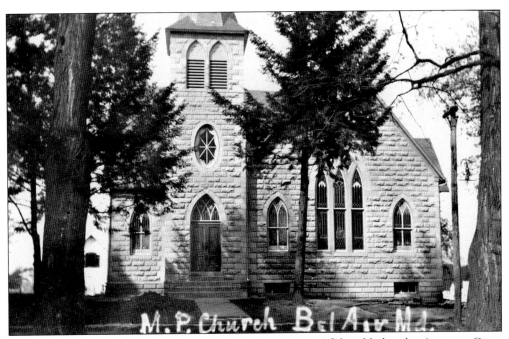

M.P. CHURCH, NORTH MAIN STREET, BEL AIR, 1911. Of the old churches in town, Grace Methodist Protestant, which stood at the southeast corner of North Main and Lee Streets, was the only one that was torn down. (Courtesy James R. Bierer.)

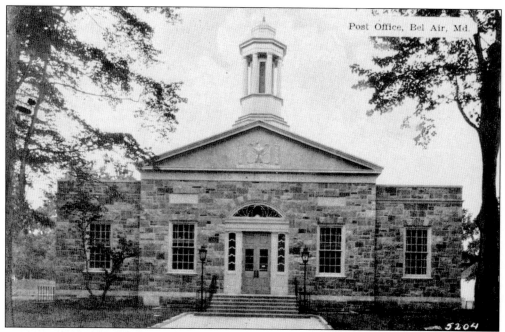

U.S. Post Office, North Main Street, Bel Air. From 1937 to 1989, this Georgian revival–style building housed the Bel Air Post Office. The only cause for complaint was its distance from the courthouse (all of four blocks away). The building now houses and is owned by the Historical Society of Harford County. (Courtesy James R. Bierer.)

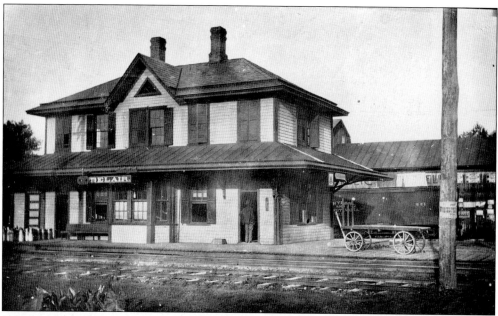

Maryland & Pennsylvania Train Station, Bel Air. Harry Hopkins recalls the sounds of the trains—shrill freight train sirens, the big bass whistle of the passenger trains, and the friendly baritone of the "Ma and Pa" coming into Bel Air Station. (Courtesy the Historical Society of Harford County, Inc.)

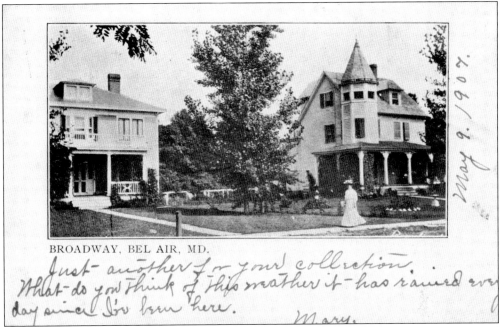

BROADWAY, BEL AIR, 1907. The Broadway homes were built by or belonged to lawyers and the wealthier inhabitants of Bel Air. Today, some of the old homes are offices. In an ironic twist, some of the comparatively smaller homes behind Hays Street and back in Frogtown are being snapped up by today's better-off folks. (Courtesy James R. Bierer.)

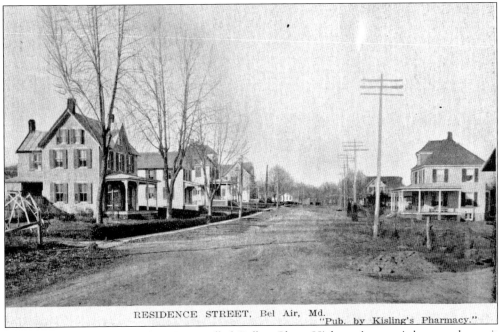

RESIDENCE STREET, BEL AIR. Later called Dallam Place, Hickory Avenue is how we know it today. (Courtesy James R. Bierer.)

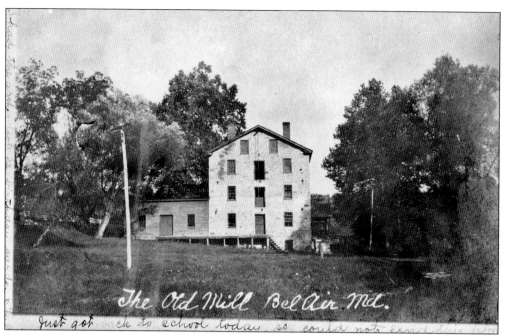

THE OLD MILL, BEL AIR, 1907. This was probably Moore's mill, which was on the site where Southampton Middle School is situated. (Courtesy James R. Bierer.)

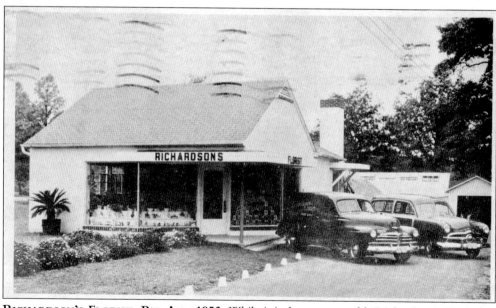

RICHARDSON'S FLORIST, BEL AIR, 1952. While it isn't a century old, Richardson's Florist has been a staple of Bel Air life for a long time. The businesses we patronize become an important part of our lives. When a business closes or changes hands, we can feel a space in our lives, like an old friend is gone. (Courtesy James R. Bierer.)

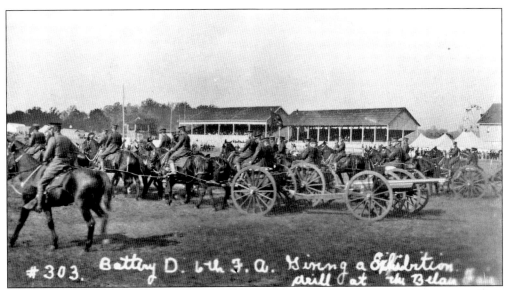

BATTERY D GIVING AN EXHIBITION DRILL AT THE BEL AIR FAIR. Bel Air's own artillery unit of the Maryland National Guard, Company D, served from the Civil War to Vietnam. Behind the race track grandstands are the fairgrounds, fenced off by a wooden wall, as Harry Hopkins recalls. Bowen Weisheit remembers climbing a tree to jump over the wall when a young boy. (Courtesy the Historical Society of Harford County, Inc.)

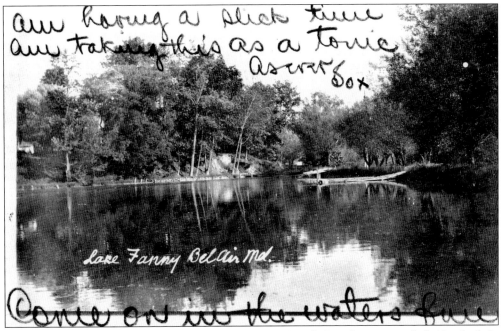

LAKE FANNY, BEL AIR, 1906. Route 1 goes over Winter's Run by means of a bridge built in 1930. Previously, Route 1 went over Winter's Run on a bridge that still exists but has been disconnected from the main road. When the Winter's Run Dam was created for the water supply to Bel Air, the water that used to fill Lake Fanny dwindled to a trickle. (Courtesy James R. Bierer.)

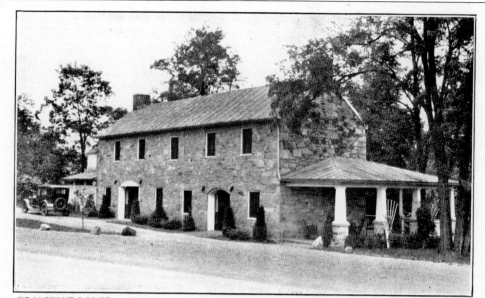

GRAYSTONE LODGE, on U. S. Route 1. 2 Miles South of Bel Air, Maryland, 20 Miles North of Baltimore. Good Food. Comfortable Rooms, with Coil Spring Beds and Inner Spring Mattresses. Restful Porches.

GRAYSTONE LODGE, SOUTH OF BEL AIR. Why stay at a camp or cabin when you could spend the night here on a coil spring bed with inner-spring mattress? It probably had to do with price. The current owner of the lodge plans to restore it to its former glory as a place to enjoy good food and a room. (Courtesy the Historical Society of Harford County, Inc.)

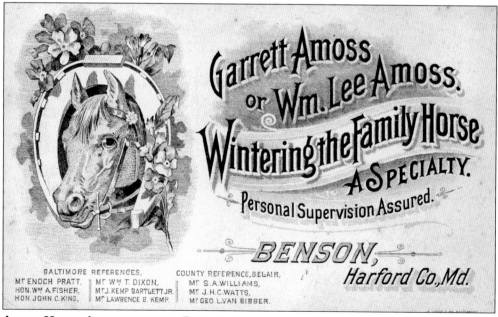

AMOSS HORSE ADVERTISEMENT, BENSON. Benson is known today for the state police barracks and the fine homes that lie behind it. But at one time everything was either farm or woods, so Benson was home to a horse farm fine enough to include Enoch Pratt on its client list. (Courtesy the Historical Society of Harford County, Inc.)

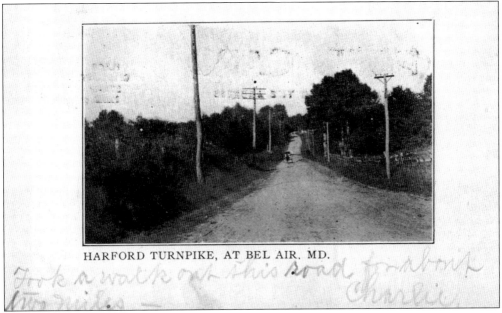

HARFORD TURNPIKE AT BEL AIR, 1907. Today we're used to the crazy blending of Harford Road and Bel Air Road onto the Baltimore National Pike and into Bel Air at Benson. In 1907, the sender of this card took a walk on the road for about two miles. (Courtesy James R. Bierer.)

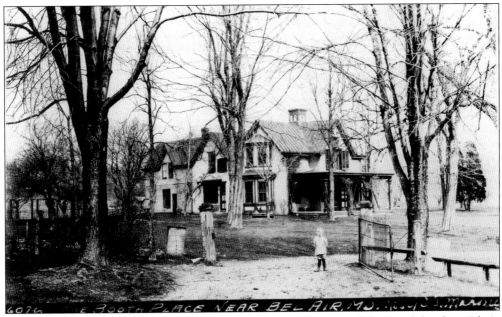

THE BOOTH PLACE NEAR BEL AIR. A cautionary tale, the story of the Booth brothers Edwin and John (there was a third brother and two sisters also) shows in one family the fame that comes from devotion to one's craft (Edwin the actor) and the infamy that comes from fanatical devotion to one's cause (John the assassin). (Courtesy James R. Bierer.)

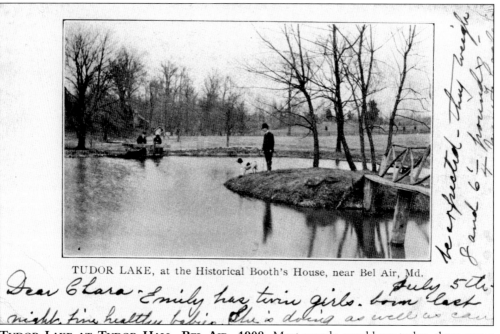

TUDOR LAKE AT TUDOR HALL, BEL AIR, 1908. Most people would say today, there was a lake back there? If not for a postcard, we might not have a visual record of this and other rare glimpses into Harford's past. (Courtesy James R. Bierer.)

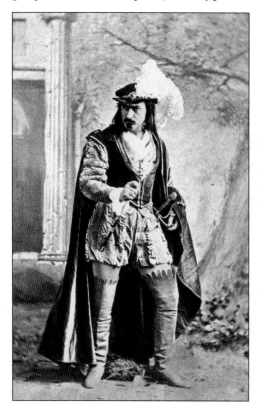

EDWIN BOOTH. Edwin Booth's reputation as one of the great actors of all time has to be taken on the word of others and on his fame. It is a pity that he was active before the age of film and tape. That he was Harford grown is a point of pride as great as the shame brought on by his brother's murder of President Lincoln. (Author's collection.)

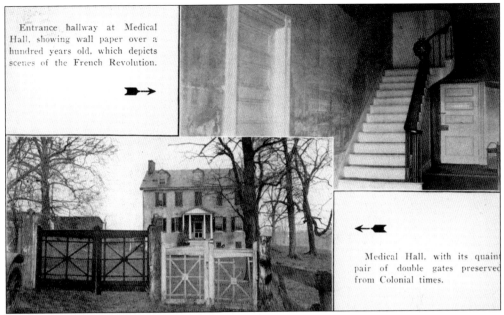

MEDICAL HALL, BEL AIR. This card reads: "Medical Hall was the birthplace in 1741, and until 1810 the residence, of Dr. John Archer, first graduate of medicine in America and Revolutionary patriot. . . . Here Dr. Archer conducted a school of medicine, and hence the name given the place." The home is on Thomas Run Road. (Courtesy the Historical Society of Harford County, Inc.)

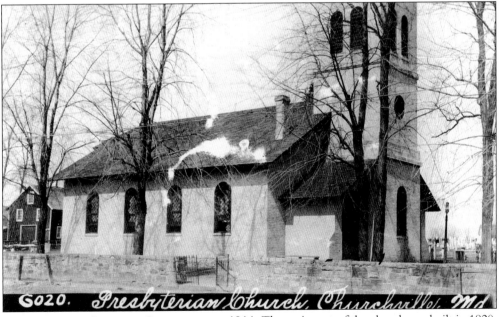

PRESBYTERIAN CHURCH, CHURCHVILLE, 1914. The main part of the church was built in 1820. When this photo was taken, even the tower was pretty new (1870). This and many other old Harford County churches remind us daily of the deep roots that many communities and families have here. (Courtesy the Historical Society of Harford County, Inc.)

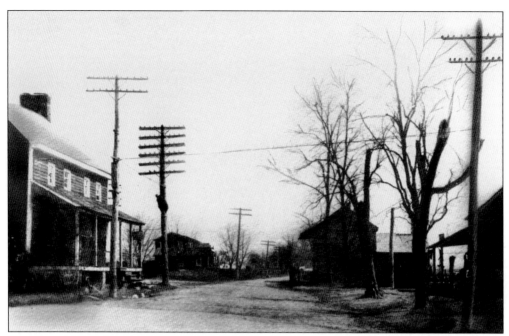

HAVRE DE GRACE ROAD, CHURCHVILLE. In recent years, the turn onto Route 155—the Havre de Grace Road—has been shifted a few hundred feet east, but the stretch of road pictured here was in that space. You can see the road turning to the right in this *c.* 1910 card, as it does today. (Courtesy Walter G. Coale, Inc.)

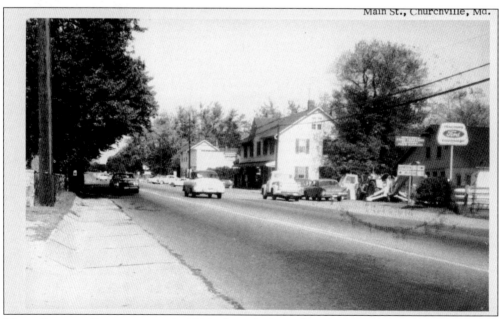

MAIN STREET, CHURCHVILLE. In 1900, if you had stood by the street side of the Presbyterian church and looked across the road, you would have seen the buildings shown on this 1950s-era card. Walter G. Coale, Inc., still sells farm and construction equipment, although the building was remodeled in 1998. (Courtesy the Historical Society of Harford County, Inc.)

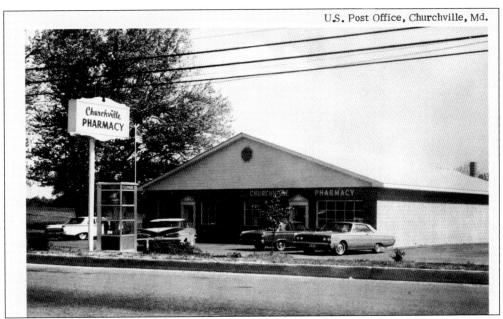

U.S. Post Office and Pharmacy, Churchville. What is most striking about this photo is how similar small town pharmacies appear. Jarrettsville Pharmacy today could pass for the twin of this one. (Courtesy the Historical Society of Harford County, Inc.)

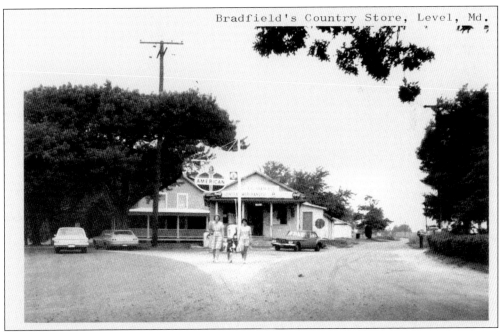

Bradfield's Country Store, Level. As we've seen, major crossroads were good places to open a business. You'd expect to find a hotel, a blacksmith and wheelwright to keep your wagon and buggy rolling, and a store. The store made the transition to an automotive society by adding a gas pump. A rare few general stores still exist in Harford County. (Courtesy the Historical Society of Harford County, Inc.)

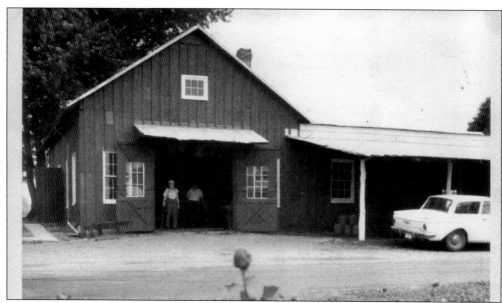

FOARD'S BLACKSMITH SHOP, LEVEL. Northwest of Havre de Grace, the town of Level is mostly rural farmland. The historic blacksmith shop here was moved to Steppingstone Farm, a county-owned property devoted to preserving a working farm of the early 1800s. Demonstrations of the farm, including the working blacksmith shop, are given weekends in season. (Courtesy Linda Noll, Steppingstone Museum.)

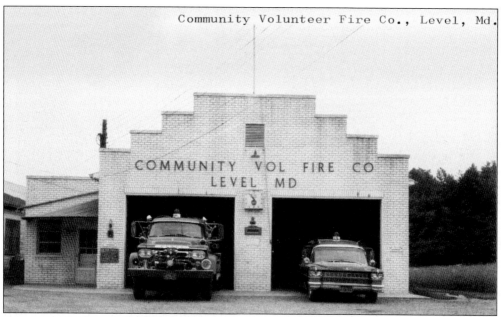

COMMUNITY VOLUNTEER FIRE COMPANY, LEVEL. Like many of the county's volunteer fire companies, Level's has upgraded its building and equipment. At the heart of each company are the dedicated firefighters and EMTs who protect their community. Many families have served through the generations. These companies are a great source of community pride. (Courtesy the Historical Society of Harford County, Inc.)

Eight
WATERVALE, FALLSTON, AND LADEW

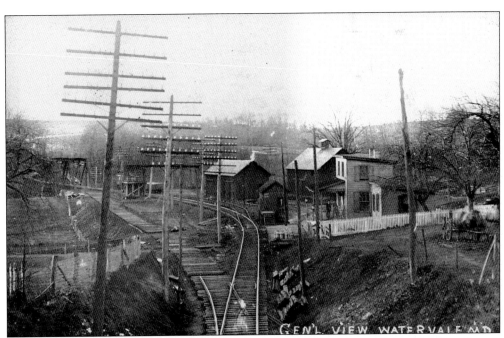

GENERAL VIEW, WATERVALE. At the intersection of Vale and Watervale Roads today, there is a historic one-lane wooden bridge. Riding over it, one can imagine when the area between Fallston and Tollgate Road was part of the Maryland & Pennsylvania Railroad. (Courtesy the Historical Society of Harford County, Inc.)

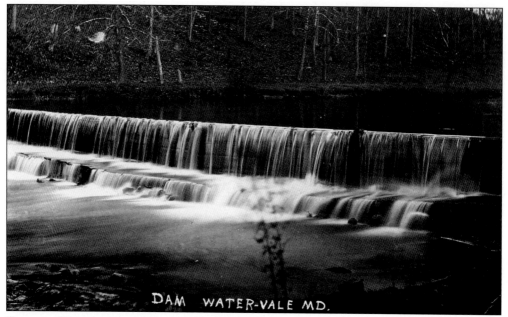

DAM AT WATERVALE, 1910. Another beautiful image reminds us of the importance of water for farming and livestock. (Courtesy the Historical Society of Harford County, Inc.)

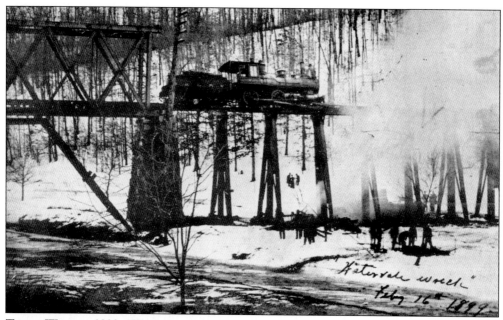

TRAIN WRECK, 1899, WATERVALE. Wooden trestles made for spectacular accidents, as seen in this photo, which memorializes the Winter's Run trestle disaster of 1899 at Watervale, one of three major trestle accidents on the Ma and Pa in the 1890s. (Courtesy the Historical Society of Harford County, Inc.)

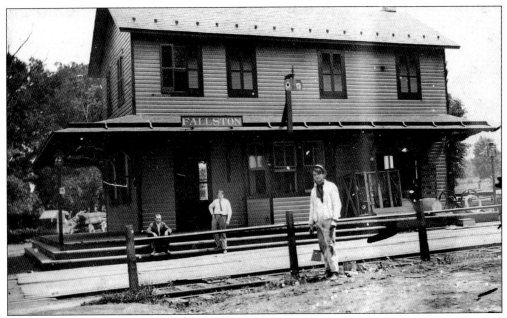

TRAIN STATION, FALLSTON. Next stop, Fallston! This real photo postcard captures in sharp detail what the waiting must have been like. The man sitting on the steps seems resigned to the wait with nothing else to do. The younger man puts his hand in his pocket, maybe to reach for his watch to check the time. The young man in the foreground, a railway company worker, seems glad to stand still for a moment. (Courtesy the Historical Society of Harford County, Inc.)

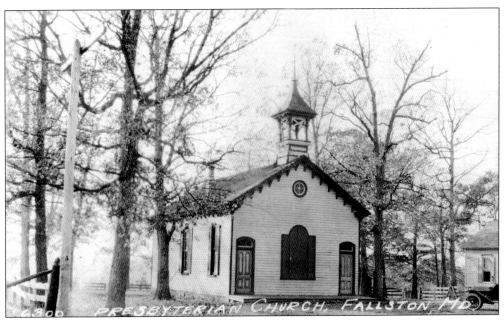

PRESBYTERIAN CHURCH, FALLSTON. This was the seed of the building that has sprung up, altering the simplicity of the original, although it is still a friendly and inviting structure on Fallston Road (Route 152) near Connolly Road. (Courtesy James R. Bierer.)

P.E. Church, Fallston. Called Prince of Peace, this church looks much the same today. The stable visible in the photo below does not show up in this photo. Perhaps it had not been built yet. The horse and wagon clearly are ready for passengers, though. And the congregation, though small, certainly looks gregarious. (Courtesy the Historical Society of Harford County, Inc.)

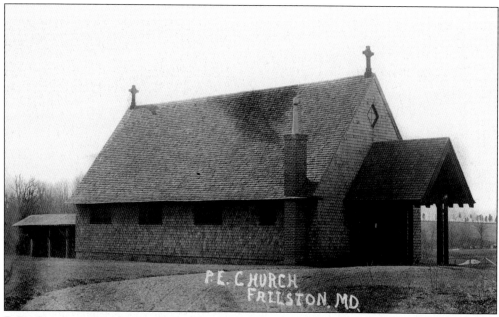

P.E. Church, Fallston, 1911. The sender says the local churches are "small but pretty," which is a fair estimation of most of the church buildings in the area in 1911. As town populations have grown, especially in the last half of the 1900s, most churches have had to add on, rebuild, or relocate to accommodate more parishioners. Notice the stable behind the church. (Courtesy the Historical Society of Harford County, Inc.)

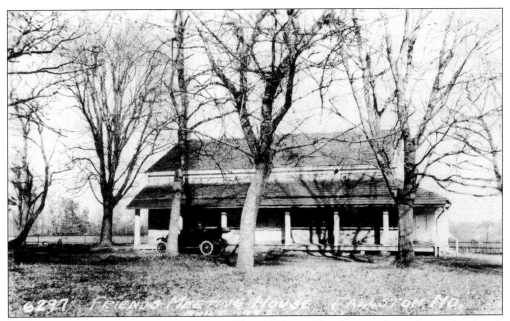

FRIENDS MEETING HOUSE, FALLSTON. The 1843 meeting house pictured was the fourth structure built on the grounds the Quakers got in 1749. This photo is less artistic than the one below but perhaps more brutally honest, especially in the glare of the winter sun. At any rate, it shows the difference the photographer makes in postcard production. (Courtesy the Historical Society of Harford County, Inc.)

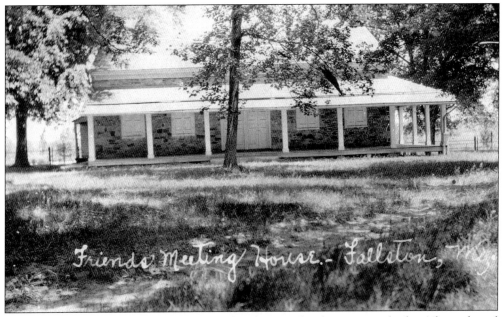

FRIENDS MEETING HOUSE, FALLSTON. The photographer has got exactly the right angle and waited for exactly the right lighting to brighten the stone—difficult to do with the wraparound porch. The men and women entered from opposite doors and sat in separate areas. (Courtesy the Historical Society of Harford County, Inc.)

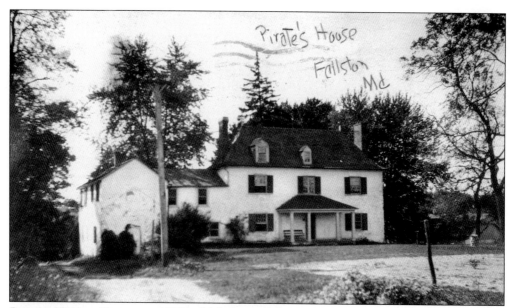

PIRATE HOUSE, FALLSTON, 1933. Rich from a life at sea, a pirate settled down and built this house. Used to sleeping in a hammock on his ship, he hung a hammock between two hooks on the walls of his bedroom and slept in it. Neighbors dug for his gold after he died but never found any. (Courtesy the Historical Society of Harford County, Inc.)

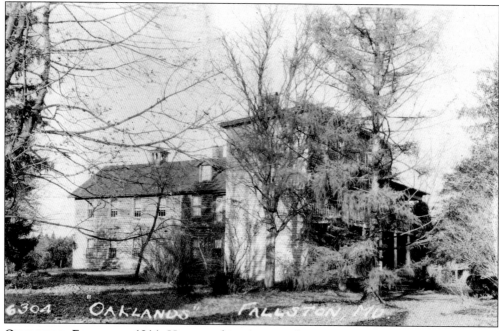

OAKLANDS, FALLSTON, 1914. Home to the private academy Curtiss School during the last half of the 1800s, the home stood until the mid-1990s, when it burned. (Courtesy the Historical Society of Harford County, Inc.)

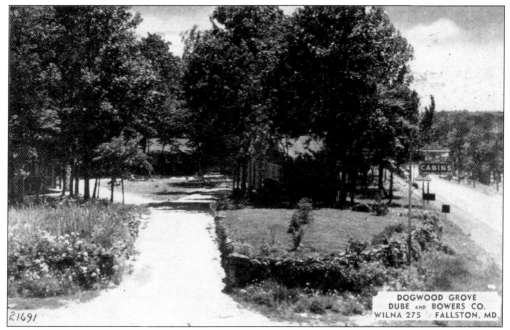

DOGWOOD GROVE, DUBE AND BOWERS COMPANY, FALLSTON. When the auto replaced the horse, the family was able to drive freely. Not having to care for a horse on a trip must have been liberating. Outdoor campgrounds became the rage for travelers. (Courtesy the Historical Society of Harford County, Inc.)

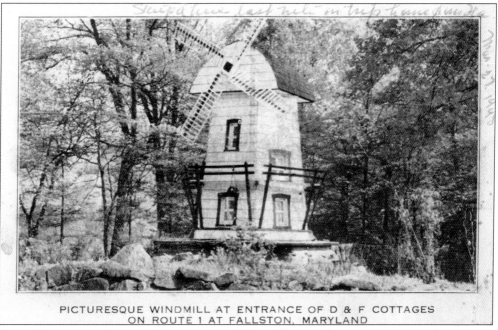

D&F COTTAGES, ROUTE 1, FALLSTON, 1948. Following the camp craze was the cottage. Cottages were one step up from camping but eventually improved, adding heat and running water. (Courtesy the Historical Society of Harford County, Inc.)

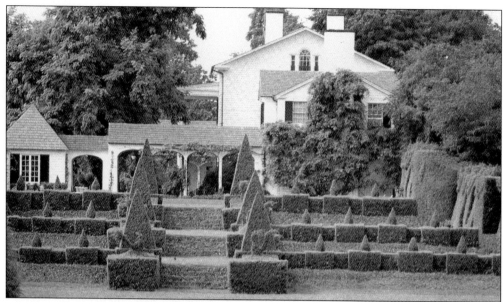

LADEW MANSION AND TOPIARY GARDEN, TAYLOR. The Taylor post office is a bit of a misnomer today. Monkton is the post office for the Ladew area. Part of the My Lady's Manor tract of land, the Pleasant Valley House bought in 1929 by Harvey Ladew is squarely in horse country. Harvey's old money, bachelor lifestyle meant all play and no work. Fox hunting and English gardens were his passions. (Author's collection.)

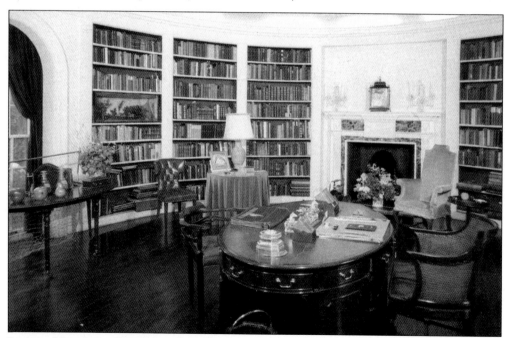

LADEW MANSION, LIBRARY, TAYLOR. Though he lived as a bachelor, Harvey Ladew had many friends visit for hunting, such as the Duke and Duchess of Windsor and the former King Edward VIII and the divorcée for whom he abdicated the throne of England, Wallace Warfield Simpson. His grand library and gardens attest to his elegant tastes. (Author's collection.)

Nine
Jarrettsville to Rocks and Deer Creek

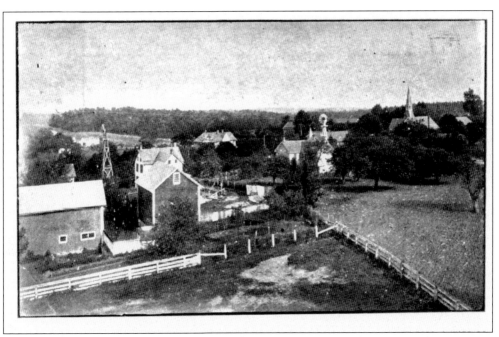

Bird's Eye View, Jarrettsville, 1910. Luther Jarrett had bought up much of the land in the village known as Carman (he bought much of it from descendants of Amos Carman). He built the grand Jarrett Manor on the northeast corner of the crossroads (where the Station House and 7-Eleven have been for some years now), so he had the post office name changed to Jarrettsville. Richard Sherrill thinks the high point of view that this photo was taken from must have been the top of Jarrettsville High School. The steeple of Asbury Methodist Church is at the top right of the frame. (Courtesy the Historical Society of Harford County, Inc.)

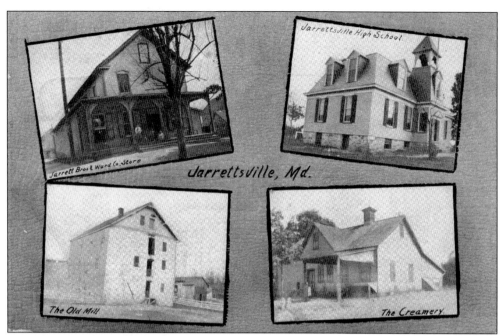

FOUR BUILDINGS, JARRETTSVILLE, 1912. The four buildings are the Jarrett Bros. and Ward Store, the Jarrettsville High School, the Old Mill, and the Creamery. (Courtesy the Historical Society of Harford County, Inc.)

JARRETT BROS. & WARD STORE, JARRETTSVILLE, 1906. Someone has scraped off the writing on the front of the card. (Until 1907, by law, you could only write the address on the back of a postcard but not a message.) But the image is clear enough. The store was on the southeast corner, across from the Jarrett Manor. A Citgo gas station is there now. (Courtesy the Historical Society of Harford County, Inc.)

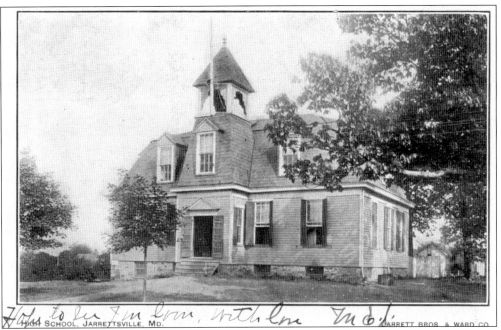

HIGH SCHOOL, JARRETTSVILLE, 1908. This 1903 building was replaced by a brick one in 1928. North Harford High School replaced it and other local high schools when it opened. (Courtesy James R. Bierer.)

MAPLE AVENUE, JARRETTSVILLE, 1908. Maple Avenue must have run parallel to Jarrettsville Road, intersecting the current Route 165 (Baldwin Mill Road.) Looking past the Jarrett Bros. and Ward Store to the left and straight down Maple, you can see the steeple of Calvary M.E. Church. (Courtesy the Historical Society of Harford County, Inc.)

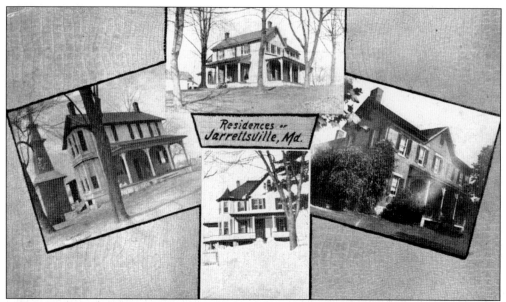

FOUR RESIDENCES, JARRETTSVILLE, 1913. While unidentified on the card, we know the Jarrett Manor—the home on the right—was made of brick. Benjamin Kurtz remembers visiting the huge house as a small boy. The home boasted a spiral staircase with a handsome wood railing that went up to the third floor. (Courtesy the Historical Society of Harford County, Inc.)

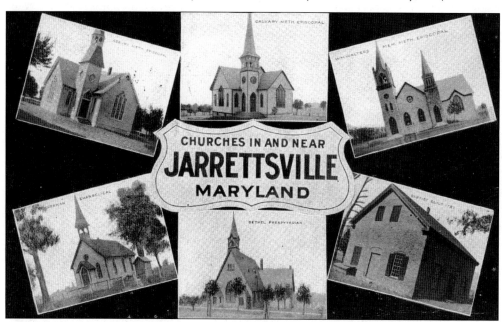

CHURCHES IN AND NEAR JARRETTSVILLE, 1911. From the top left, clockwise, they are Asbury Methodist Episcopal, Calvary Methodist Episcopal, William Watters Memorial Methodist Episcopal, the Old Brick Baptist Meeting House (built in 1754, though the card says 1781, and the oldest standing church in the county), Bethel Presbyterian, and German Evangelical, called Salem, as in Salem Church Road, where just the cemetery remains. (Courtesy the Historical Society of Harford County, Inc.)

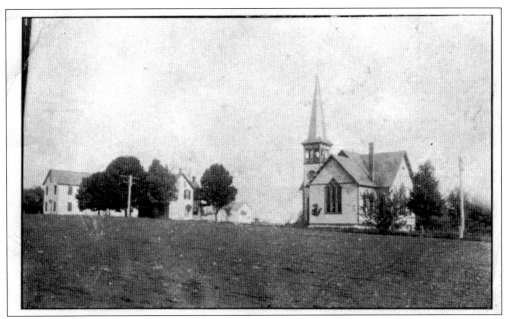

TOWN HALL, PARSONAGE, AND M.E. CHURCH SOUTH, JARRETTSVILLE, 1910. Calvary M.E. was organized by Southern sympathizers after the Civil War in 1869. They built the church pictured here in 1896. It burned in 1934, and the Asbury congregation invited Calvary to worship with them until a new church could be built. (Courtesy the Historical Society of Harford County, Inc.)

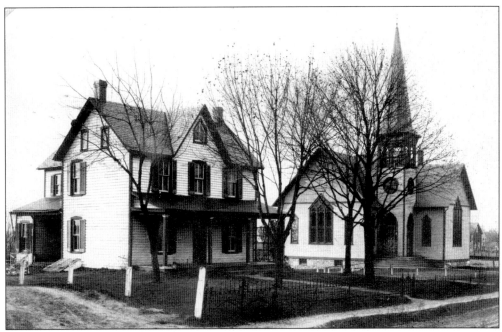

CALVARY M.E. CHURCH AND PARSONAGE, JARRETTSVILLE. Once the new church was built in 1935, the two congregations decided to unite and moved into the new stone church under the name Jarrettsville (United) Methodist Church. (Courtesy James R. Bierer.)

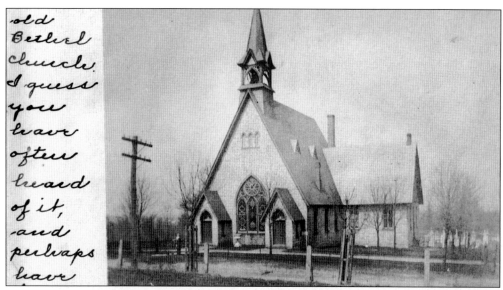

BETHEL PRESBYTERIAN CHURCH, JARRETTSVILLE, 1907. As far back as 1761, the area then called Upper Node Forest had a congregation of worshipers at Bethel. In 1888, they built the current stone church building—their fourth. This was the oldest postcard image found. In later ones, the trees, almost as tall as the steeple, block the beautiful central window. (Courtesy the Historical Society of Harford County, Inc.)

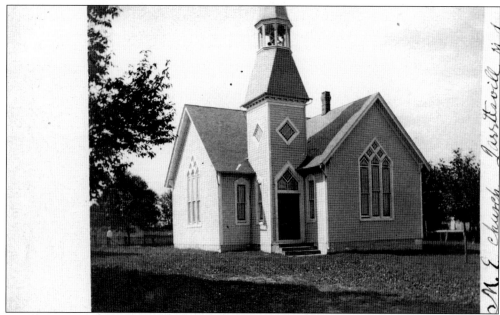

ASBURY METHODIST EPISCOPAL CHURCH, JARRETTSVILLE. Once the Asbury and Calvary congregations united and moved, the E.G. Kurtz and Son Funeral Home bought the property and moved their business from across the street, where their furniture-making shop and funeral home had been since 1844. After a fire in 2000, Benjamin and M. Gladden Kurtz restored the soaring chapel ceiling space, which had previously been closed off. (Courtesy the Historical Society of Harford County, Inc.)

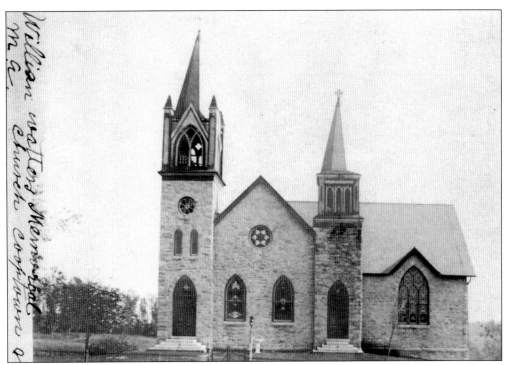

WILLIAM WATTERS MEMORIAL METHODIST EPISCOPAL CHURCH, COOPTOWN. The first church on this spot was built in 1844 and was called Eden Chapel. The current church, made of granite, was built in 1898. According to C. Milton Wright, Cooptown is named for Captain Coops, an early settler in the area. (Courtesy the Historical Society of Harford County, Inc.)

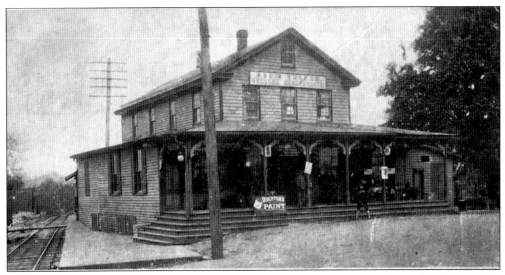

STORE AND RAILROAD STATION, FOREST HILL. Roe & Tucker General Merchandise was the store and train station in one. The building still sits on the corner of Rocks Road and Jarrettsville Road. In the 1920s, Klein's opened its first store there—you can still see the name painted on the roof, done to give early aviators a landmark for navigation. (Courtesy the Historical Society of Harford County, Inc.)

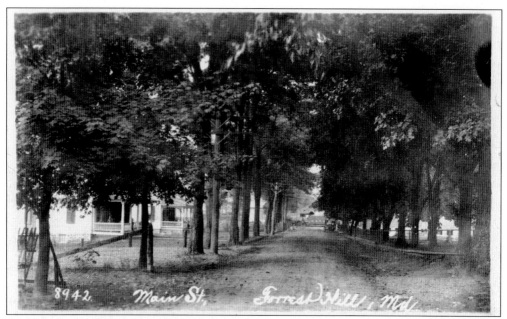

MAIN STREET, FOREST HILL, 1915. This incredible postcard shows, in the very center of Main Street—Rocks Road today—the train pulling out of the station, which would be to the right side of the road (blocked by trees). Much of the locomotive and the front half of the coal car are visible. A woman sits on her porch at left. (Courtesy Marlene Herculson.)

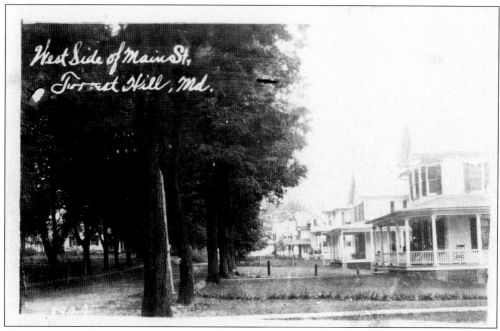

WEST SIDE OF MAIN STREET, FOREST HILL, 1915. Another rare card from the same year, this shows the homes with their wonderful porches, rockers on each one and decorative plants on some. Even though an auto was in the photo above, hitching posts line the street and are in some of the yards. (Courtesy Mary L. Martin Ltd.)

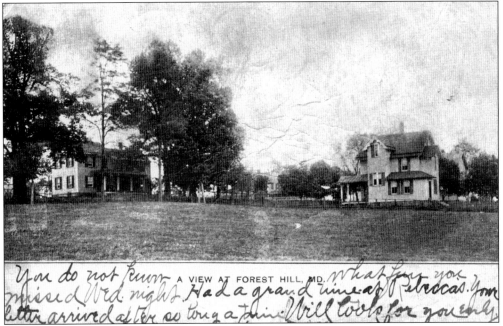

A VIEW AT FOREST HILL, 1907. The next few photos show some more of the homes at Forest Hill. If Forest Hill is named for the forest that used to be there, then the two trees flanking the house to the left must have been left standing from that forest. (Courtesy the Historical Society of Harford County, Inc.)

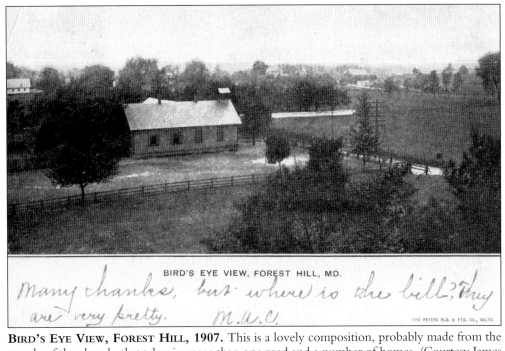

BIRD'S EYE VIEW, FOREST HILL, 1907. This is a lovely composition, probably made from the steeple of the church, that takes in more than one road and a number of homes. (Courtesy James R. Bierer.)

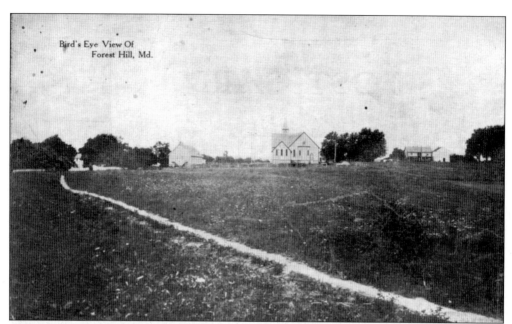

BIRD'S EYE VIEW, FOREST HILL. This is more of a fisheye view. The white stripe is a footpath across the field, and several homes and a church lie on the horizon. (Courtesy the Historical Society of Harford County, Inc.)

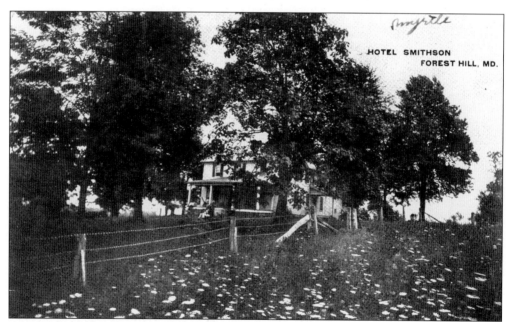

HOTEL SMITHSON, FOREST HILL, 1910. Too bad the photographer didn't have a zoom lens. The people on the porch (perhaps a woman and child) seem especially animated, pointing in the sky or making bubbles. It's hard to tell. But the Queen Anne's lace in the foreground is pretty. One of the previous postcards is addressed to someone in care of Mrs. Smithson. (Courtesy the Historical Society of Harford County, Inc.)

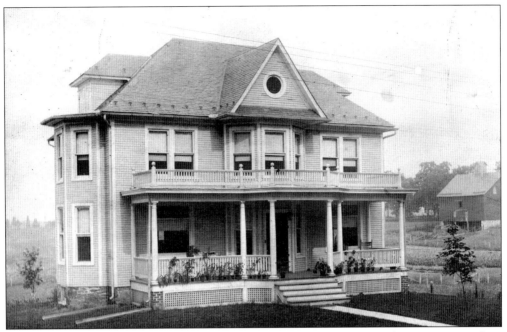

RESIDENCE, FOREST HILL, 1912. Here's a lady who liked feedback: "This is a picture of my home. I tho't maybe you had never seen the original. . . . Expect to start (in the auto) on the 20th for Luray Caves Virginia. Will be away the rest of the week. What do you think of the trip?" (Courtesy the Historical Society of Harford County, Inc.)

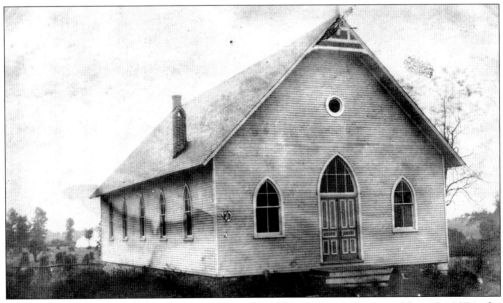

WOMEN'S CHRISTIAN TEMPERANCE UNION (WCTU) HALL, FOREST HILL. In 1874, the WCTU gave women a means of joining together to make changes in society. Their target was alcohol, on which Americans annually spent over a $1 billion (versus $900 million on meat and under $200 million on schools). (Courtesy the Historical Society of Harford County, Inc.)

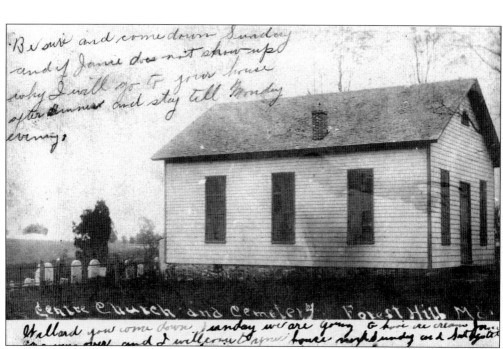

CENTRE CHURCH AND CEMETERY, FOREST HILL, 1907. The message reads in part: "Be sure and come down Sunday and if Janie does not show up why I will go to your house after dinner and stay till Monday evening." The 1865 building pictured here was last used in 1907, before the current structure was built. (Courtesy the Historical Society of Harford County, Inc.)

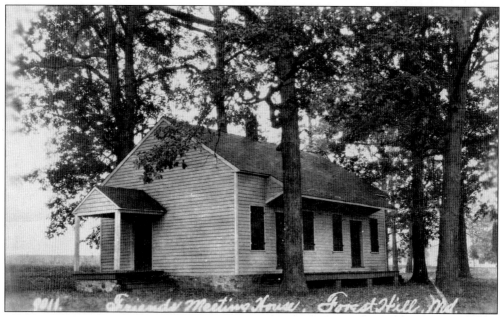

FRIENDS MEETING HOUSE, FOREST HILL. As we've seen, Quakers settled in various parts of the county. This meeting house was built in the mid-1800s and survived for over a century. (Courtesy the Historical Society of Harford County, Inc.)

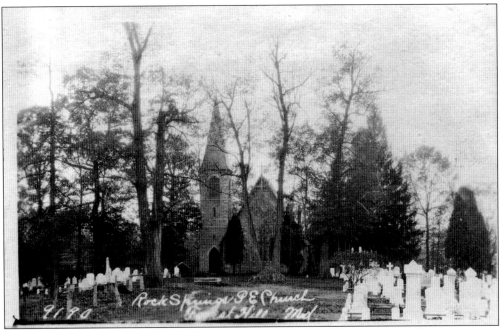

ROCK SPRING P.E. CHURCH, FOREST HILL. The scary graveyard scene from the movie *Tuck Everlasting* was filmed in the church cemetery. Some of the graves date from the early 1800s, when the church was formed. (Courtesy the Historical Society of Harford County, Inc.)

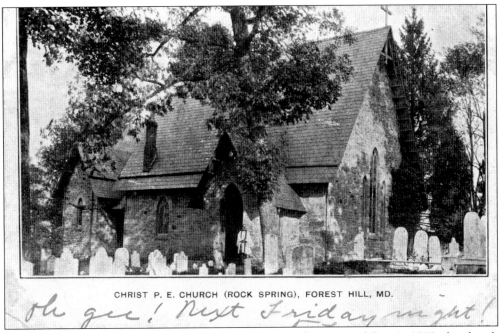

CHRIST P.E. (ROCK SPRING), FOREST HILL, 1908. After a remodeling in 1875, the church added the tower. The message on front of the postcard reads, "Oh gee! Next Friday night!" (Courtesy the Historical Society of Harford County, Inc.)

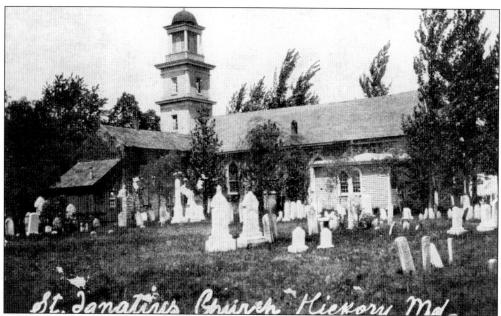

ST. IGNATIUS CHURCH, HICKORY, 1909. The land was bought in 1779, the church was built in 1793, and it has kept growing ever since. Seeing its golden dome from afar is a blessing, especially as the sky through Hickory and north Bel Air becomes filled with glowing gasoline signs and giant neon mini-storage locks. (Courtesy the Historical Society of Harford County, Inc.)

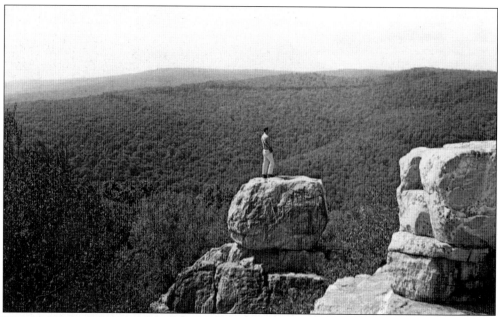

ROCKS OVERLOOKING THE DEER CREEK VALLEY, ROCKS. There is a place where you can get away from it all. The card states: "The Rocks of Deer Creek form a sheer cliff 150 feet high separated by a gorge through which Deer Creek flows. Known as the King and Queen Seats, these great pillar-like rocks were the site of Susquehannock Indian councils." (Courtesy the Historical Society of Harford County, Inc.)

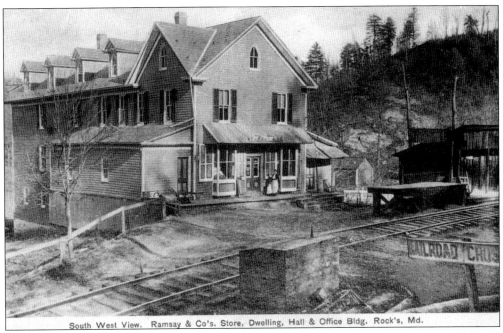

South West View. Ramsay & Co's. Store, Dwelling, Hall & Office Bldg. Rock's, Md.

RAMSAY & COMPANY STORE, DWELLING, HALL & OFFICE BUILDING, ROCKS, 1911. In addition to having a store, a hall—like a reception site—and offices (Ramsay was very entrepreneurial), this must have been a destination for travelers as well. In a message on one of the cards, a woman says she had a wonderful stay here. (Courtesy the Historical Society of Harford County, Inc.)

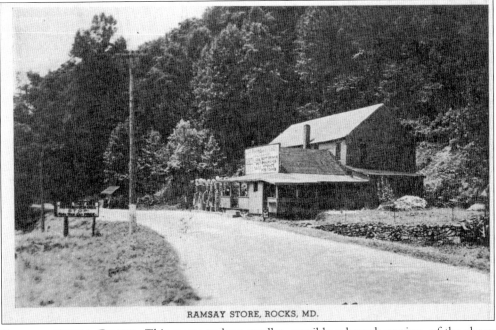

RAMSAY STORE, ROCKS, MD.

RAMSAY STORE, ROCKS. This seems to be a smaller, possibly a branch version, of the above location, on the road for convenience to travelers. (Courtesy James R. Bierer.)

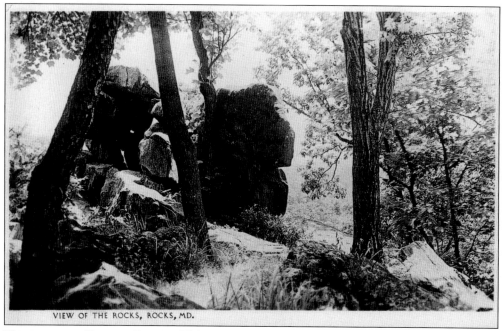

VIEW OF THE ROCKS, ROCKS. This gorgeous, World War I–era photo reminds one of the timelessness of nature during conflict. (Courtesy James R. Bierer.)

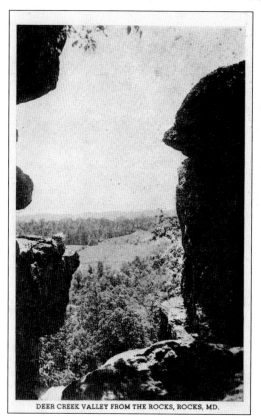

DEER CREEK VALLEY FROM THE ROCKS, ROCKS. This early photo of the valley is from the relatively safe perspective standing between the King and Queen Seats. (Courtesy the Historical Society of Harford County, Inc.)

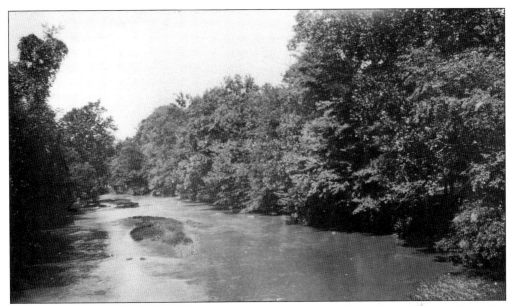

DEER CREEK, ROCKS. The history of our ancestors would have been very different without the waters that flow throughout the land and are still ours to enjoy today, one of the natural wonders of Harford County. (Courtesy the Historical Society of Harford County, Inc.)

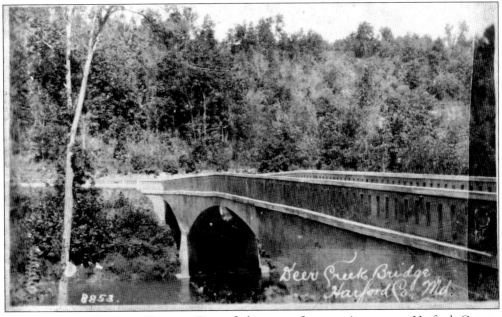

DEER CREEK BRIDGE, ROCKS. One of the most frequent images on Harford County postcards, the Deer Creek Bridge appears on photo postcards, as here, and especially on tinted postcards, where the beautiful scenery is reproduced as bright color printed on a simplified photo design to mimic a painting. The postmark is illegible but is probably around 1907. (Courtesy James R. Bierer.)

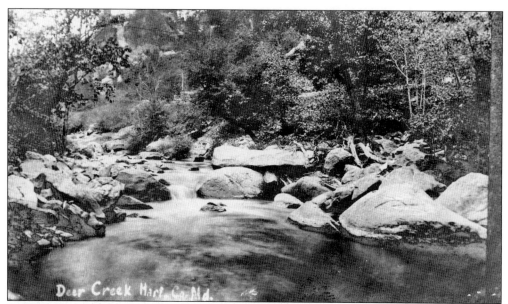

DEER CREEK, ROCKS, 1908. More of Deer Creek's beauty is pictured here as water glides down a natural waterfall. Sometimes nature needs no commentary. Take a picnic lunch, drive out to Rocks State Park, pull off the road near picnic tables by Deer Creek, and enjoy the view and sounds. Ignore the cars and trucks. Go hiking if you want to get away from the traffic. (Courtesy James R. Bierer.)

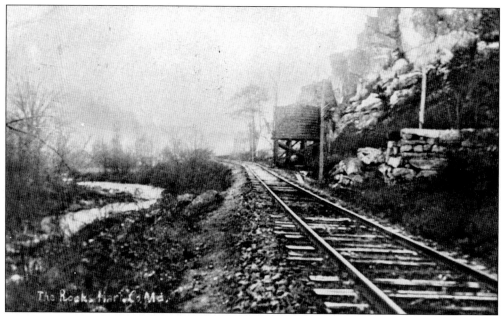

WATER TANK, ROCKS, 1909. The water tank was used by the railroad when the Ma and Pa line ran through the park. There are a number of postcards where the tank is photographed head on, but it gets lost in the greenery around it. This unique card photographs it from the side, in profile, for better visibility. Someone thought this was postcard worthy. (Courtesy James R. Bierer.)

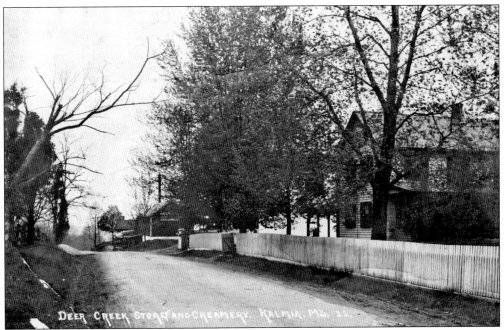

DEER CREEK STORE AND CREAMERY, KALMIA, 1916. Creameries appeared all over the county for a while. Farmers brought their milk to be processed or it was collected by truck. The milk was heated, the cream separated from the milk and churned for butter, and both sold locally or shipped to Baltimore. (Courtesy the Historical Society of Harford County, Inc.)

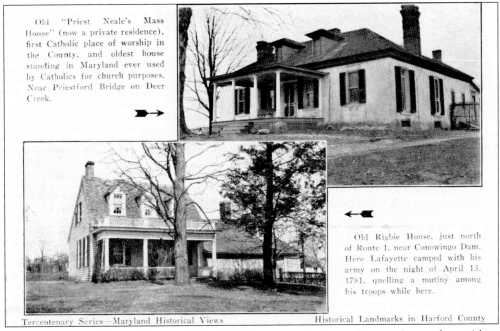

TERCENTENARY SERIES: PRIEST NEALE'S HOUSE AND RIGBIE HOUSE. It was the parish at Priest Neale's that created the early mission parish that became St. Ignatius Church in Hickory. (Courtesy the Historical Society of Harford County, Inc.)

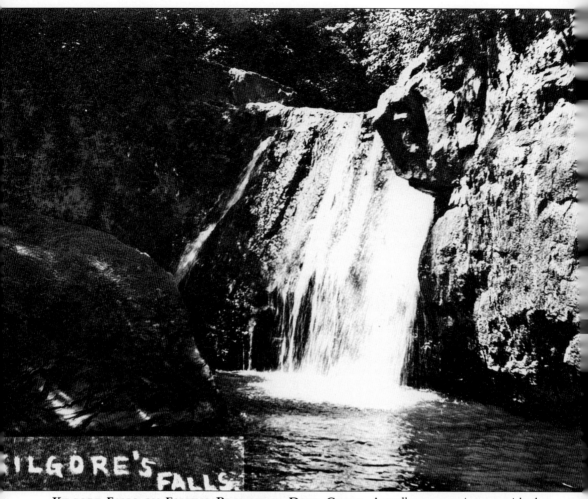

KILGORE FALLS ON FALLING BRANCH OF DEER CREEK. Actually not contiguous with the main portion of the park, the falls is southwest of the North Harford School complex. This is appropriate because students helped lead the effort to protect the falls, which were on privately owned ground. This is the famous waterfall used for the movie *Tuck Everlasting*. (Courtesy the Historical Society of Harford County, Inc.)

Ten
PORTRAITS, ADS, AND MORE

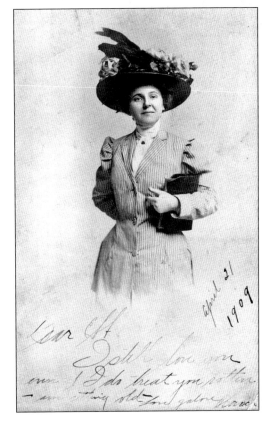

PORTRAIT OF BLANCHE ROBERTS, 1909. The humanity and humor in these next three cards are great. This is a portrait of friendship, love, and life in the early 1900s. "Dear Eff, I still love you even if I do treat you rotten—am getting old—Love galore." (Courtesy the Historical Society of Harford County, Inc.)

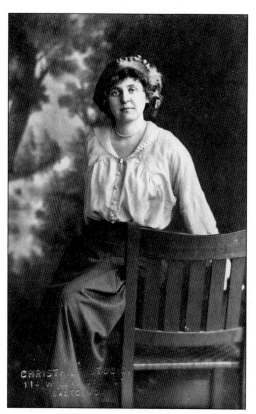

PORTRAIT OF BLANCHE ROBERTS. This card states, "Dear Elva, You see I am getting older and fatter every day." (Courtesy the Historical Society of Harford County, Inc.)

PORTRAIT OF ROBERTS CHILDREN. This postcard says, "J. Carroll Roberts, 3 yr 2 months Ensfield Roberts 1 yr 11 months." On back is: "This is only a postal. I have a nice photo for you if I can ever get Carroll to send it." (Courtesy the Historical Society of Harford County, Inc.)

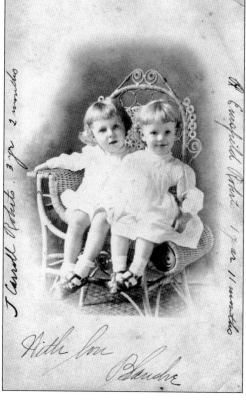

PORTRAIT OF JOHN RICHARDSON(?). There is a question mark on the identification of this photo postcard. The young man seems ready for work. (Courtesy the Historical Society of Harford County, Inc.)

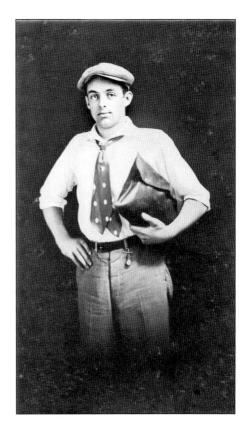

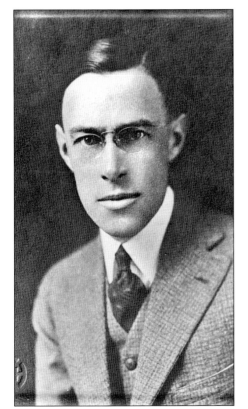

PORTRAIT OF MILLARD E. TYDINGS. This is an early portrait of the Havre de Grace native and senator. Tydings is credited with crafting the documents that led to Philippine independence. As such, he is as well known and respected in that country as George Washington is in the United States. (Courtesy the Historical Society of Harford County, Inc.)

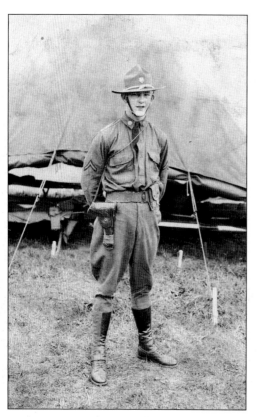

ARMY SOLDIER. Since this card came from a local collection, the soldier in the photo may have been from Harford County or assigned to APG. However, there is no identification on the card. (Courtesy the Historical Society of Harford County, Inc.)

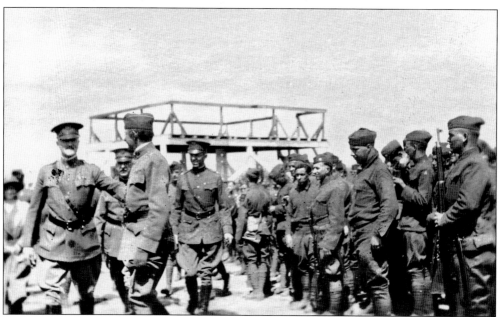

GENERAL PERSHING WITH TROOPS. Along with newspapers and radio, postcards like this one helped keep the folks back home in touch with events and personalities of World War I. (Courtesy the Historical Society of Harford County, Inc.)

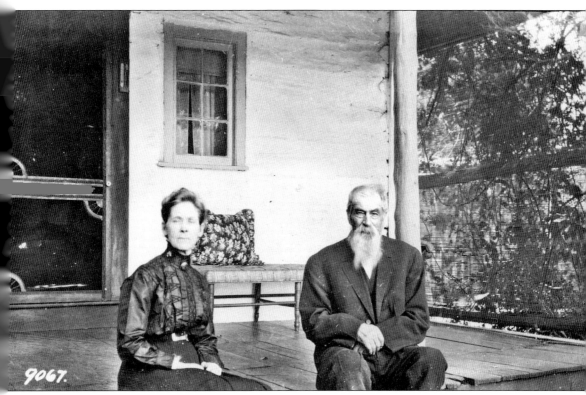

MR. AND MRS. PARKER FORWOOD. A note on the back identifies the couple and says "near Carsin's Run." It is a striking portrait of two people who seem to have strong personalities. (Courtesy the Historical Society of Harford County, Inc.)

First Day's Fight, Reynold's Woods, Gettysburg, Pennsylvania, 1910. The back reads, "In the early stage of the First Day's battle a Confederate force attempted to force their way through Reynold's Woods and gain the rear of the Union troops. . . . After a severe struggle in the woods along Willoughby Run the Confederates were overwhelmed, and their commander, General [James] Archer, and the greater part of his command taken prisoners." (Courtesy the Historical Society of Harford County, Inc.)

Mutual Fire Insurance Company Premium Payment Notice, 1895. As far back as its founding in 1824, the Mutual Fire Insurance Company in Harford County has protected businesses and homes. We know it today as the Harford Mutual Insurance Company. Businesses seemed to use postcards frequently for purposes we might consider private today, such as mailing bills. (Courtesy the Historical Society of Harford County, Inc.)

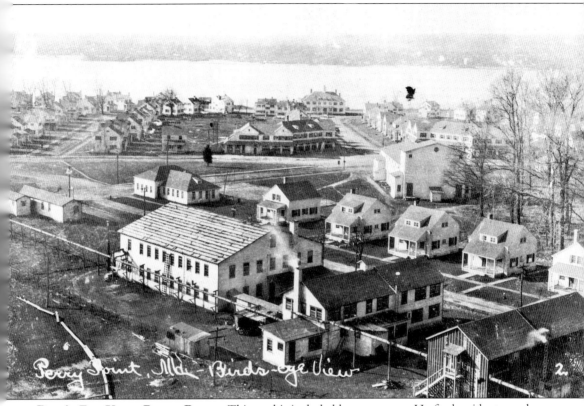

BIRD'S EYE VIEW, PERRY POINT. This card is included because many Harford residents work for the Veterans Association in Perry Point in Cecil County. Havre de Grace is across the river in the background. (Courtesy the Historical Society of Harford County, Inc.)

POSTCARD TO HENRY ARCHER, 1874. This pre-picture postcard is shared for its age, June 9, 1874, and the fame of its recipient, Henry Archer. It looks like it's time for someone to pay the lawyers: "What will we charge our client for obtaining judgment by confession in Russell v Maynadecs[?]. Send me bill. V. Rufus Gill." (Courtesy the Historical Society of Harford County, Inc.)

REVERSE OF 1874 POSTCARD. Henry was the grandson of Dr. James Archer of Medical Hall. Henry's sons, William and James, owned and lived at their estate, called Shamrock, in Bel Air. (Courtesy the Historical Society of Harford County, Inc.)

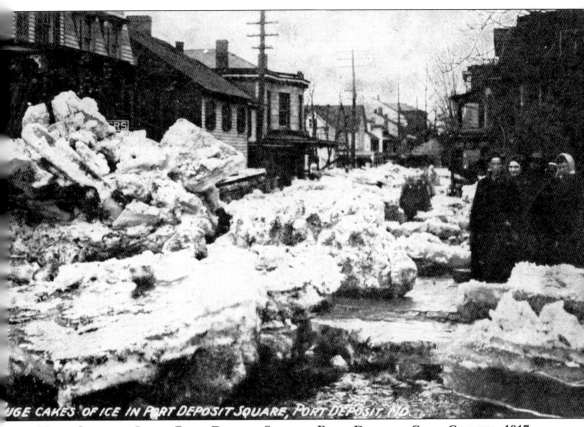

HUGE CAKES OF ICE IN PORT DEPOSIT SQUARE, PORT DEPOSIT, CECIL COUNTY, 1917.
The ice floe pictures from Havre de Grace are incredible, but the streets of Port Deposit, right across the Susquehanna from the Lapidum area, are built so close to the river that these ice chunks would ram through their streets and then cause flooding during the spring thaw. In this card, residents pose with the uninvited guests. (Courtesy the Historical Society of Harford County, Inc.)

Established 22 Years.

The latest style in Dentistry is Old Teeth Capped with Gold and Teeth without Plates. (Removeable.)

Gold Filling a Specialty!

We never wedge the Teeth before filling, Teeth filled and Extracted without pain by the use of DR. WILSON'S Vitalized Air, made fresh every day, anyone can take it with safety, young or old. Sets of Teeth on Gold Plate or Porcelain at bottom prices.

A good set of Teeth, - - - - - $5.00
Best set of Teeth on Rubber, - - - $8.00
☞ None better made no matter how much you pay.
Teeth Extracted, - - - - - 25 Cents.
Vitalized Air administered, - - 50 "
Teeth Filled with Gold, - - - - $1.00 up.
" " " Alloy, - - - 50 Cents.
" " " Silver, - - - 75 "
" " " Porcelain, - - 75 Cts. up.

OFFICES:

No. 313 North Charles St., Baltimore, Md.
No. 24 Baltimore Street, Cumberland, Md.
Gross Block, Main Street, Frostburg, Md.
Link's House, Hyndman, Pa.

Branches of the Western Maryland Dental Association.

☞ People from abroad can come in the morning and wear their New Teeth home the same day.

DR. L. B. WILSON,
(Manager of this Office.)

☞ **OFFICE OPEN ALL HOURS.** ☜

DENTAL ADVERTISEMENT POSTCARD. This card probably comes from the early 1900s, but no date is on it. It does put into perspective pricing and advertising promises—some things change greatly while others seem never to change. (Author's collection.)

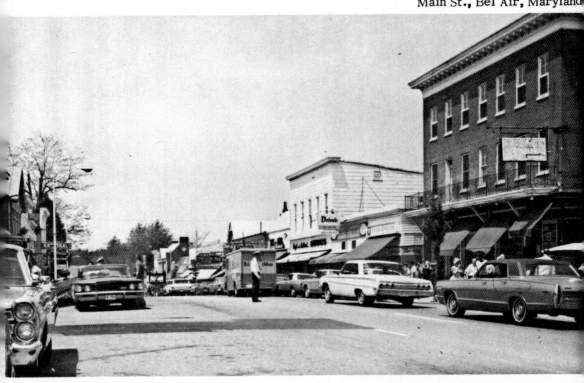

Main Street Traffic, Bel Air. In coming months, Main Street will have its first major repaving since 1979. The two-way traffic shown on this postcard is a reminder that driving through town has never been easy, at least in modern times. Bill Seccurro remembers that one double-parked delivery truck would wreck the flow of traffic until the driver was ready to move. (Courtesy Gene and Mary Streett, Boyd & Fulford.)

SHOE STORE AD, 1939. This postcard ad went to a Fallston resident. A pair of $9.95 shoes was top of the line in 1939. Prices may have changed, but wingtips still look the same. (Courtesy the Historical Society of Harford County, Inc.)

TUCKAWAY MANOR MOTEL, ABERDEEN. Here is a classic motel postcard. This linen-finish card is tinted in lovely pastels. The 1940s motel offered "40 luxuriously furnished rooms complete with Television—Simmons Pastel Furniture and Beauty-Rest box springs and mattresses. Wall-to-wall carpet. Fireproof Construction—Private Ceramic tile baths [pink with black trim tiles], hot-air heat, city water and cross ventilation—telephones—air-conditioning. For reservations call Aberdeen 1070, 1071, or 1072." Note the rounded TV screen. Thirza Brandt and others say that folks made fun with the name Tuckaway. (Author's collection.)

First Night in the Country

FIRST NIGHT IN THE COUNTRY, 1957. This joke postcard must have been on target for the sender. Her message was simply, "This is it. Wish you were here." For some, this might bring back memories of visiting grandparents or even memories of your own home. Harford has become a mix of the old and new, and much has changed forever, but we are fortunate that, when visitors passed through or residents needed to send a quick note, they chose to send picture postcards to keep memories alive—for them and for us. (Author's collection.)